To all of the angels in my life, and the good Lord who provided them.

Thanks to:
My family: Mark, Shelbi, Jason, Shari, Geneva, Ted, Dan, Karen, and Aunt Lu
Julie Lynch, who helped me put together many quilts
Manya Powell, who collaborated on the large angel quilt
Pam Clarke, my wonderful machine quilter
The many friends who took the angel challenge and who agreed to be part of this book
In The Beginning Fabrics
JHB Buttons, which provided just the right buttons for my quilts

*Every visible thing in this world
is put in the charge of an angel.*

ST. AUGUSTINE

Contents

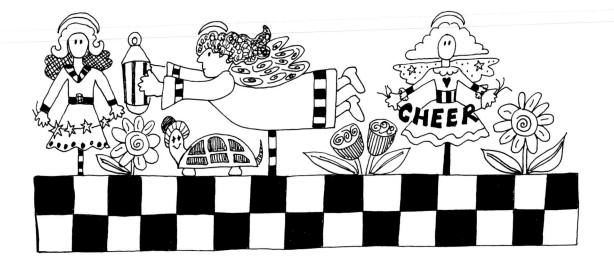

Dear Creative Friend:

I'd like to invite you to join my creative challenge and make a quilt showing your guardian angel.

I've created a basic body pattern (see pages 86–87) as well as some small, whimsical angel patterns (see pages 88–96) that you can use, if you want, as a starting point. To begin, choose a theme. What is your mental image of your everyday angel? Think about what I call "quilters' clues," the props you can include to communicate your theme. For more ideas, see "Heavenly Steps to Extraordinary Quilts," beginning on page 65.

Don't feel limited to the patterns in this book. This is your chance to be creative. If you live a fast-paced life, get your angel moving. Turn your angel on her side so she's flying. If you're a water fan, your angel may have a fish tail.

Don't forget that angels, like people, can be any color. What is your favorite color? Maybe your angel is yellow, blue, or purple.

Don't forget to include your angel's halo and wings! Think about different ways to include your theme in your angel's wings, halo, and clothing. What kind of wings would a butterfly angel have? There are infinite heavenly ideas just waiting for you.

And finally, don't forget embellishments.

Thank you for being willing to have fun with creativity. I know your angel quilt will be wonderful.

Mary Lou

For every soul, there is a guardian watching it.

THE KORAN

Introduction

Why write a book about angels? Partly for fun and partly because I believe there are angels all around us, helping us every day. My belief in everyday angels began as a child. When my grandparents came to visit, my grandmother would tuck me into bed at night and remind me that my angel would sit on the end of my bed until I woke up. According to Grandma, my angel watched over me night and day, guarding and protecting me.

My grandparents' home was a wonderful place to visit, especially the angel tree in the backyard. My grandfather told my brother and me that the angels rested in that tree, and if we'd sit and watch, we'd see their shadows in the branches. I watched that tree for many years, and more than once, I thought I saw the shadow of an angel moving about. Grandpa claimed he saw them every day.

I think an angel tree is a delightful idea. In our backyard is an old cherry tree. On more than one occasion, I've seen shadows that I imagined were my family's angels, chatting together while they waited for their heavenly orders.

I've thought about writing a book about these everyday angels—angels in disguise—for several years. But I was disappointed with what I found when I began researching the idea. In most stories, the angels are lovely, ethereal creatures with flowing hair, feathery wings, and long gowns. The images conjure up visions of softness, goodness, puffy white clouds, and harp music. In my mind, angels are sent by God to be messengers, to be attentive, to be encouraging, and possibly to get us out of trouble. Now, don't get me wrong. I think angels can be soft and beautiful with radiant light and huge wings, too. I know people who have described angel sightings as "huge angel, big wings, gorgeous light, flowing hair, beautiful skin, and fabulous eyes." But, to my way of thinking, there is another variation of God's special messengers.

I also think that angels are sent in human form, so we don't realize they're angels. Think of the people you saw this week. Could someone you know be an angel in disguise? This idea and invitation to creativity is the focus of the everyday angels shown in the extraordinary quilts in this book.

Take a minute to look through the book (if you haven't already). Quiltmakers from all over the United States and Canada joined me in a creative challenge, and the resulting quilts are as different as their makers. So what does this challenge mean to you? This book provides ideas on how to be creative, and how to design and make an original angel quilt showcasing your interests and identity.

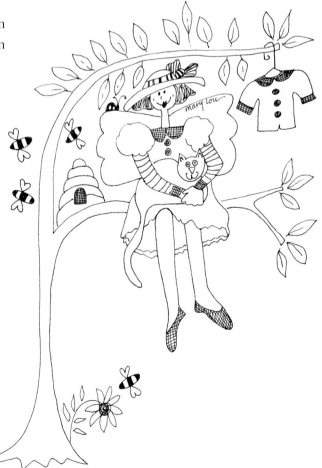

I hope that you'll join my challenge to find out how very creative you can be. Maybe the message your angel will carry to you and to others is that you are a creative and one-of-a-kind quilter.

Creative Angel Challenge

So now is a perfect chance for you to start thinking about your very own creative angel. On the following pages, you will find ideas to help you get started. Using your own unique personality and talents, your angel will say something about you and things that are important to you. Colors, fabrics, theme ideas, humor, piecing, shapes, and your own vision of angels will make your quilt unique. The fun part is expressing yourself. Maybe this could be your personal angel or an angel for someone you love. Giving yourself permission to have some fun and be creative is the first step.

The Saga of the Unfinished Quilt (*or* Why You Will Finish This Quilt)

As a teacher, I'm often asked, "Do you draft, plan out, or design everything for your quilt before you begin?" No! And I have a very good reason why not.

How many unfinished quilts or projects do you have tucked away? If you've been quilting for more than a year, I can guarantee that most of you have at least one, if not many, projects put neatly away.

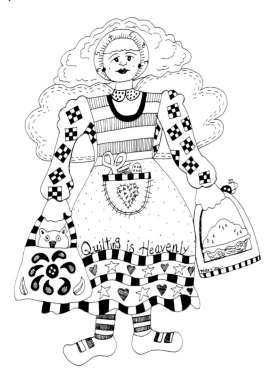

I have a theory about this. I've been quilting since 1974, and I have had my share of boxes under the bed, in the closet, and on the shelves. But, amazingly, that stopped about 1990. Why? Well, when you buy a book or a pattern, you can see what the quilt looks like before you make it. You go to your local quilt shop and purchase fabrics that you just love. Then, after washing the fabrics, ironing the fabrics, and cutting out the pattern pieces, you start sewing. Once you've finished your first block, you admire how your wonderful fabrics work together. After that, you make another block and another. Pretty soon, you have a nice stack of blocks lying end to end on the floor or a design wall. You take time, you stand back, and you see how your finished quilt will look. Once the mystery is over, you start to lose interest. Now you're anxious to look for a new pattern and, even better, a new pile of fabulous fabrics.

How do I know this? Because my local quilt shop was delighted every time I walked through the door. They could be sure I was there for a new pattern and new fabrics to go along with it. I was addicted to the highs of patterns and fabrics and hated finishing anything I had taken the mystery out of.

After I started making story quilts, I changed my methods. I found that if I had the spark of an idea and worked on only one or two figures at a time, I stayed interested. And as I added to my quilt, I came up with amazing new ideas.

So don't try to draft, plan out, or design everything before you begin. Leave room for mystery and anticipation, and you'll be interested until the very end! Once you make a quilt like this, you'll want to do it again and again.

Remember, what is important to you today will change tomorrow. And who you see today will be different from who you see tomorrow. This is part of what makes story quilts such fun—your ideas and inspirations change from day to day, and so do your quilts.

Seeing Is Believing (*or* You Are an Artist)

Many quiltmakers are not sure how to translate their ideas into a quilt design. To start, I suggest looking for photos, illustrations, or paintings you can use for inspiration and movement. The children's section or the art section of your local library are good places to begin. The nice thing about going to the library is that you don't have to pay for the ideas that you use to "feed your artist" (the artist in your head).

Professional artists are taught that to be creative and spontaneous, they must always be looking and thinking and figuring new and different ways to design. The more you listen, read, learn, and look with an open mind, the better your chances of having an original and interesting design. These artists keep files of clippings, drawings, photos, and other artwork for ideas. Keep your own file, as well as a notebook for jotting and sketching ideas.

Don't, however, copy someone else's design or idea! As a teacher, I've heard quiltmakers say, "Oh, I'll just change it a little." If you do, you aren't enjoying your own creativity and you are infringing on that artist's copyright. If I want to build on someone else's idea, I will change it so that even the artist would never recognize his or her work in mine. You are looking for a tiny idea that will springboard you to your own, original work.

Of course, this approach leads to a discussion of "art" and "artists" and "creativity." If I asked a guild of quiltmakers, "How many artists are here tonight?" very few of them would raise their hands. If I asked a class of first graders the same question, everyone would raise their hands! Sometime after first grade, someone may have told you that you weren't an artist and you believed him or her. I'm here to tell you that *all* of us are artists!

At various times, I've taught art classes for third through sixth grades, and every piece of art was delightful. Children know that they're artists, and so they are. Not every person has the talent to be another Picasso or Rembrandt, but most of us have a talent and style of our own. Even Picasso said, "Every child is an artist. The problem is how to remain an artist once he grows up."

The secret to being artistic is believing that you are an artist—and working at your art. The more you quilt, the better you are at quilting. The more you appliqué, the better you are at appliquéing. And the more you use your creativity, the better you are at being creative!

Making Folk Art (*or* Give Yourself Permission to Have Fun)

This is a good time to bring up the idea of keeping these quilts folksy and fun. When I teach, I warn everyone against trying to make these quilts look realistic. Often, when my students are comparing their quilts, a student will say, "This doesn't work at all. What did I do wrong?" Usually, she tried to make her subject too lifelike. These pieces are meant to be whimsical and imperfect. That is what gives them their charm.

The beauty of these quilts is the story you're sharing. If someone rejects your quilt because it doesn't look realistic, then he or she is missing the point. Most people are much more interested in looking at what the angel is doing than they are in looking at lifelike arms and legs. Give yourself permission to go for it and have fun making your figures! If you can't give yourself permission, then let me. These rewarding quilts are worth the time and effort. They are a piece of you and who you are today.

The Quilts and Their Stories

I've invited many of my students and quilt-shop friends to join my angel challenge, and a few of their quilts and stories are featured here. It's wonderful to see how each person views their everyday angel. You'll notice that the quilters are all different skill levels. For some of these quilters—beginners *and* experienced—this quilt was their very first, very own quilt they had designed. It can be difficult for even experienced quilters to take this step. In fact, I find that *many* quilters who've designed something for the first time feel they somehow need to apologize. It's risky to set yourself out there for praise and criticism, but once you get over this hump, you're on your way to creative, original quilts.

When I began making my folk quilts, I had to look past the remarks of quilters who did not share my vision or understand my approach. If you can design knowing that you are learning new things for future quilts, then it becomes easier when a fellow quilter looks perplexed. Quilt stories are a process and a journey. You do not get to the final destination in one or two quilts. This is the magic of quilting—you never know what new thing you'll learn. So take some time, and enjoy looking and learning from the following everyday angels.

"All God's angels come to us disguised."

JAMES RUSSELL LOWELL

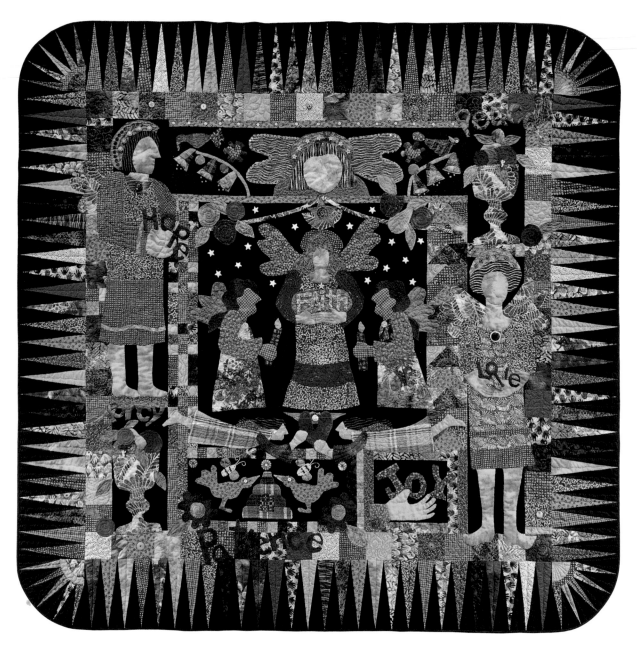

Celestial Reasonings by Mary Lou Weidman and Manya Powell, 1998, Spokane, Washington, 85½" x 87½". Quilted by Pam Clarke.

I've always wanted to make a quilt with a friend. Manya Powell is well known for her expertise in piecing fabulous quilts, and I knew I'd love what she came up with. Manya took a stack of fabric and pieced the background you see here. After I recovered from the initial shock (it's huge), I appliquéd eight angels, seven fruits of the spirit, and other little whimsical figures. Then another friend, Pam Clarke, quilted the finished top. After Manya bound the quilt, we embellished it together. It was a wonderful and creative experience for all of us, and I hope that someday we can create something wonderful and fun together again.

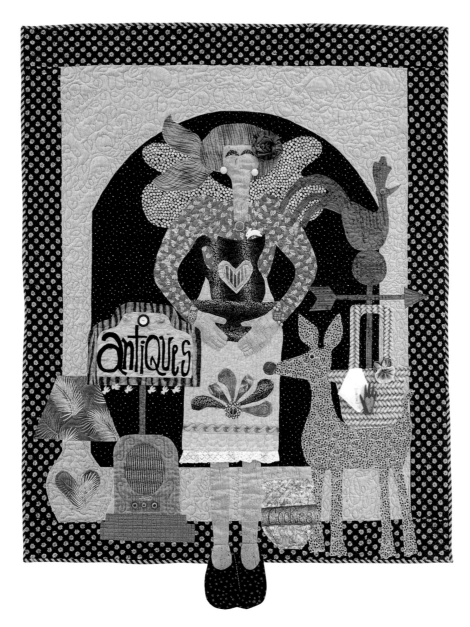

Antique Angel by Mary Lou Weidman, 1998, Spokane, Washington, 52" x 69". Quilted by Pam Clarke.

I knew when I started thinking about angels that I wanted to make an antique angel. I'm sure angels know the past and would fit into a backdrop of old things. Usually, I work with bright, fun colors. But this time, I thought I'd try a monochromatic color scheme. Using black as a window behind the angel, I pulled browns off my shelf and started cutting. Before long, my angel and antiques were basted, and I was into the appliqué. When I needed to go out of town for a workshop, I gave her to my friend Julie Lynch to work on. After she was machine quilted, I added old buttons, my grandmother's lace, and an aunt's jewelry. I love the color theme and the whimsy of this quilt. You may want to consider doing your own angel surrounded by things that you collect.

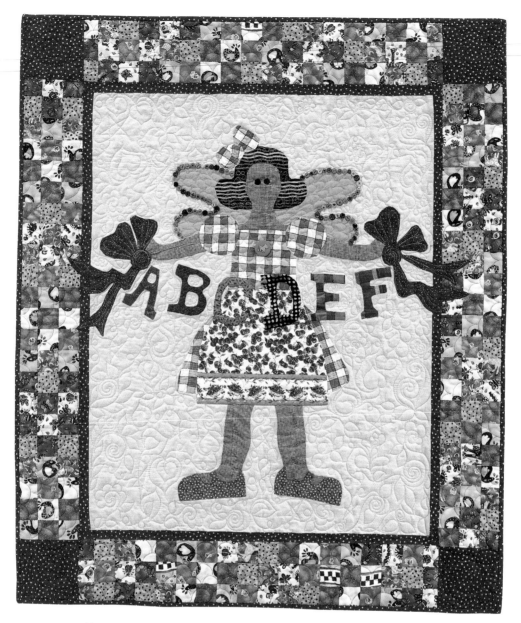

ABC Angel by Mary Lou Weidman, 1998, Spokane, Washington, 46" x 54". Quilted by Pam Clarke.

emories provide some of the best creative inspirations. I remembered the day that my youngest daughter, Shelbi, started kindergarten. She was my last child to start school, so this was a new beginning for her and an ending of sorts for me. She'll be twenty this year, but I still remember what she wore, how excited she was, and how she wanted to learn her alphabet like her older brother and sister.

I remember her looking very angelic that day in her pinafore and Mary Janes. Adding a folksy alphabet and bows made this more whimsical. I used fabrics I designed to make the perfect border. Shelbi will have this quilt to remind her of her great event. Can you think of a memory you would like to portray for someone you love?

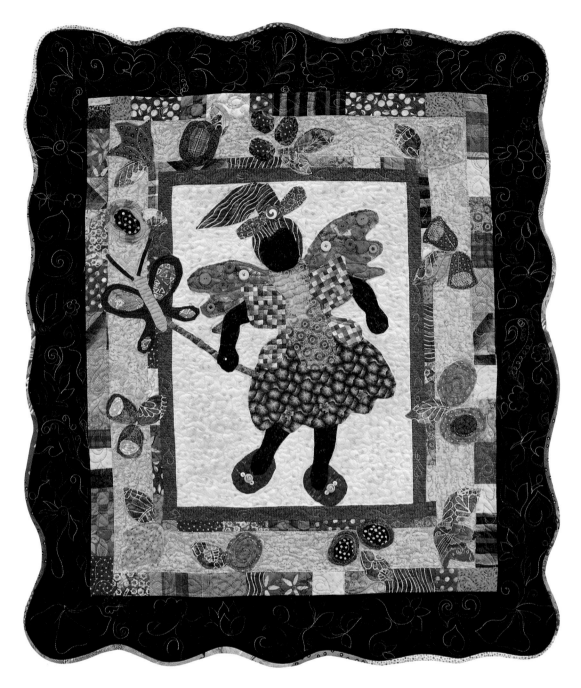

Butterfly Angel by Mary Lou Weidman, 1997, Spokane, Washington, 44" x 52½". Quilted by Pam Clarke.

As many of you know, I love color. I decided that I wanted a theme that called for great color and a little whimsy. I chose to make a butterfly that was an angel. I thought of the actress, Butterfly McQueen, who I always thought was adorable. I'm looking forward to hanging this colorful quilt in my entry hall as a spring and summer greeting to guests and family.

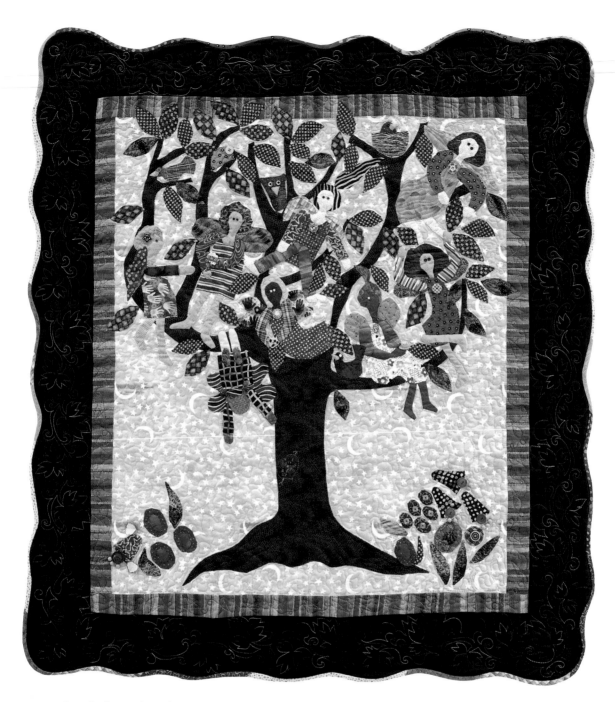

Grandpa's Angel Tree by Mary Lou Weidman, 1998, Spokane, Washington, 50" x 55". Quilted by Pam Clarke.

y grandfather had a special tree he called the "angel tree." To most folks, it was just an old apple tree, but Grandpa claimed that angels rested in the branches.

My grandfather has since passed away, but he passed this notion on to me. I often imagine I see angels resting in one of my trees, passing the time by conversing with birds and squirrels. Do you have family traditions and legends that you could include in your quilt?

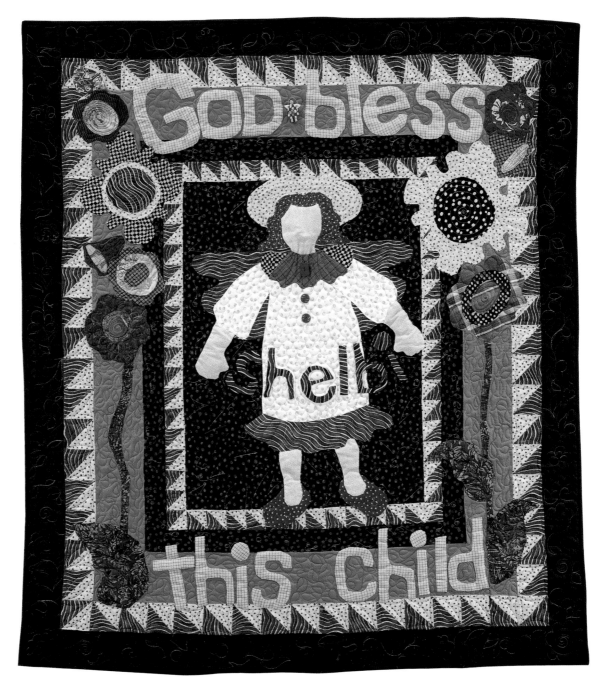

Shelbi's Guardian Angel by Mary Lou Weidman, 1998, Spokane, Washington, 53" x 61".
Quilted by Pam Clarke.

When I got samples of my first fabric line, I decided to do something really folksy just for my family. I thought that a folk quilt of an angel watching over my daughter would be nice. Shelbi's angel is surrounded by lots of things a young lady would want surrounding her.

Shelbi loves it because she appreciates the fact that her mother took time to remember her. That's the secret of doing quilts for those you love. And the best part of this quilt? The fact that it has her name in it and that it is a daily prayer of mine: "God bless this child."

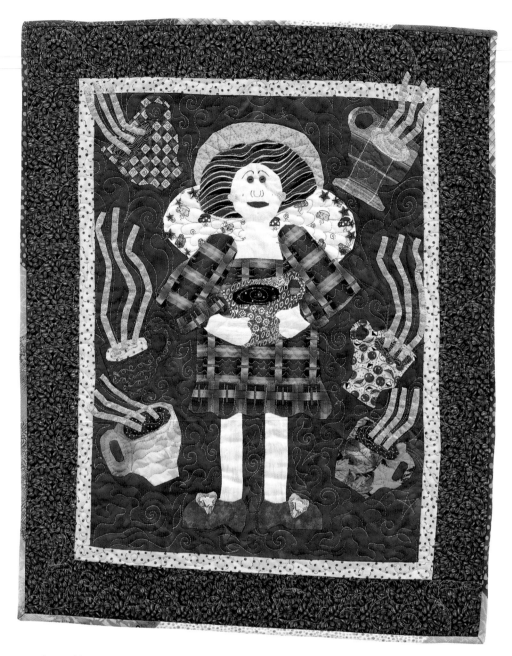

Latté Angel by Mary Lou Weidman, 1997, Spokane, Washington, 29½" x 36". Quilted by Pam Clarke.

J live in the Pacific Northwest, and I've become *very* fond of coffee and lattes. It is often rather wet and cool here, and a warm cup of java puts a smile on my face. I thought a latte angel would be a good theme because the girl at my favorite java stand is pretty much like an angel to my way of thinking.

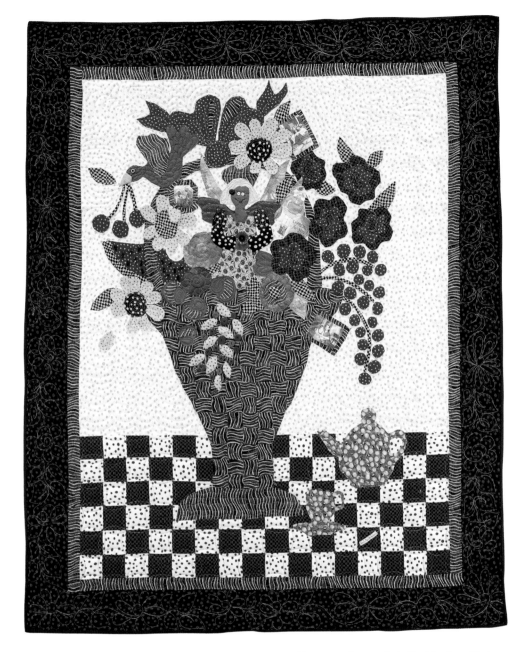

Angel Basket by Mary Lou Weidman, 1997, Spokane, Washington, 60" x 73½". Quilted by Pam Clarke.

———————

I love baskets, sentiments, and, of course, angels. When my first fabric line came out, I wanted to make a basket sampler using things I loved and techniques I teach. You'll notice that I included several photos of my family, as well as buttons from my grandmother's button box (the watermelon seeds). Sentiment is important to my quilts. I wanted this piece to be colorful and contemporary, as well as have some antique charm. The angel looking over these beloved memories makes me smile.

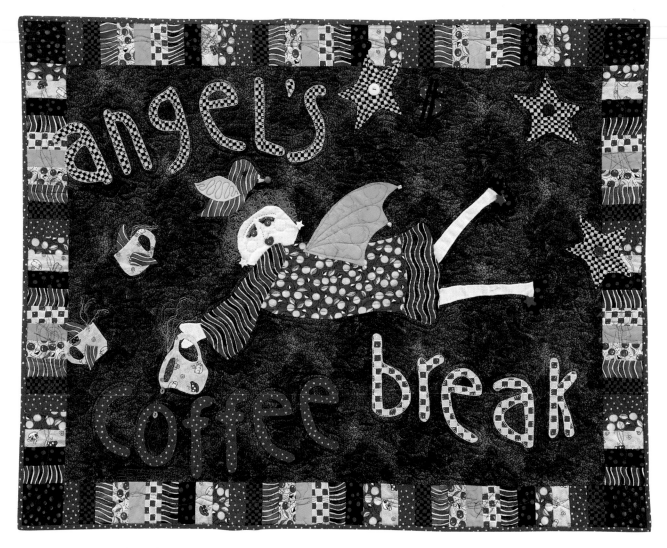

Angels' Coffee Break by Janet Paul, 1998, Edwall, Washington, 45½" x 36". Quilted by Joan McLain.

My quilt began in a class with Mary Lou. I picked a fun theme, and my quilt was well underway by the end of the class. But when I got home, I felt stuck. So I went to my bookshelf and pulled Mary Lou's book *Whimsies and Whynots: A Playful Approach to Quiltmaking.* Rereading Mary Lou's suggestions on creativity and development was all it took; I added my angel and completed my quilt.

—JANET PAUL

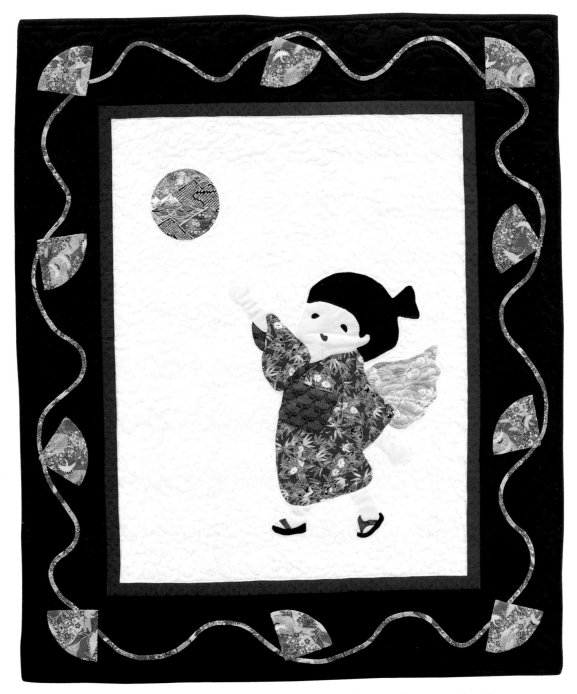

Tenshi Nokodomo by Joann Funakoshi Kliewer, 1998, Spokane, Washington, 36½" x 43".

am Japanese, and I'm interested in working in cultural themes for my quilting adventures. (I also love fabrics with an Oriental flair.) I started by drawing a child with a ball. After I completed the quilt, I asked my mother to help me name it. She suggested *Tenshi Nokodomo*, which means "angel child."

—JOANN FUNAKOSHI KLIEWER

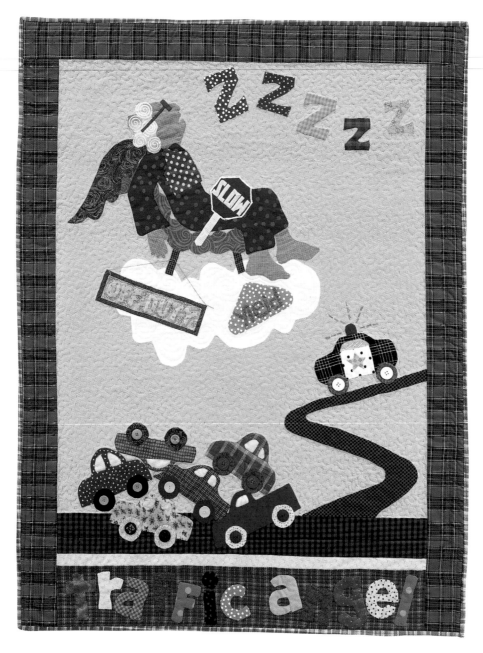

Traffic Angel by Pam Munns, 1998, Atascadero, California, 44" x 58".

In my case, picking a theme for Mary Lou's challenge was not a problem. Both my husband and I are state patrol officers in California. Our work provides us with many opportunities to help people, and I've come to believe that there are a lot of fellow officers who must be angels. With this idea in mind, I portrayed a traffic angel taking a well-deserved break. The cars are piled up, but a state patrol car is on its way to rescue those in need. This quilt will hang in my local state patrol office, and I hope it will bring smiles to the faces of those angel officers.

—PAM MUNNS

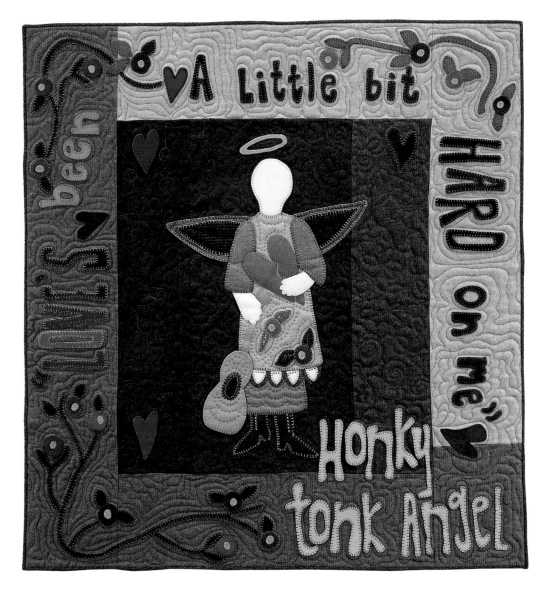

Honky-Tonk Angel by Julie Neuffer, 1998, Spokane, Washington, 45" x 47". Quilted by Pam Clarke.

I'm a traditional quiltmaker, and my experience with theme-type quilts is pretty limited. When Mary Lou asked me to create a quilt for this book, I said I didn't think I was the kind of quilter she was looking for. But Mary Lou told me not to be silly and handed me a human shape drawn on freezer paper. (It looked an awful lot like a crime-scene figure.) I agreed to try and come up with something suitable. Fortunately, coming up with my "Honky-Tonk Angel" theme was easy since I write country songs. I used the title from an old Juice Newton tune in the borders along with vines, hearts, and flowers. The fine machine quilting was done by Pam Clarke.

—JULIE NEUFFER

Author's Note: *Julie is too modest to tell you that she has a new country album out called "Brand New Pearl." It's nice to know that a talented songwriter and singer also is a creative quilter.*

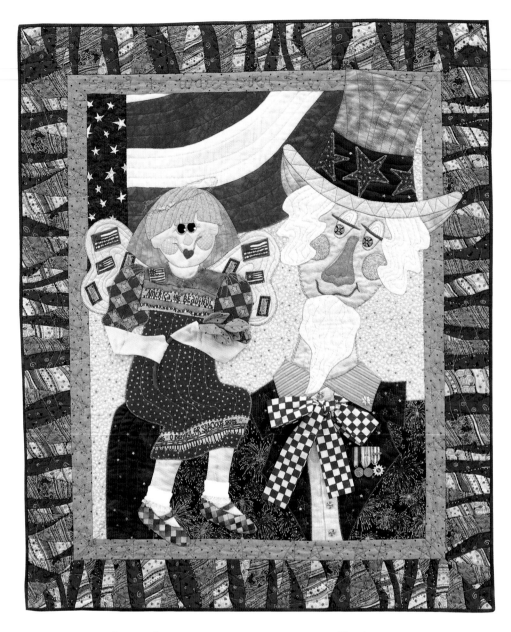

For the Boys by Susan McDermott, 1998, Lompoc, California, 34" x 41½".

I've wanted to make a quilt commemorating the men in my life for some time, and Mary Lou's challenge was the perfect opportunity.

Both my father and husband enjoyed fulfilling naval careers, my nephew is a ranger in the National Reserves, and my son is in the Army. I enjoy the thought that my loved ones are protected from harm by angels.

I began with four antique cocktail napkins that had cartoon drawings of navy and army men. I tried to use them in the quilt, but it wouldn't cooperate. Finally, I had to give up my original plan and listen to my Uncle Sam and his heavenly emissary. The napkins appear destined to be for inspiration only!

—SUSAN McDERMOTT

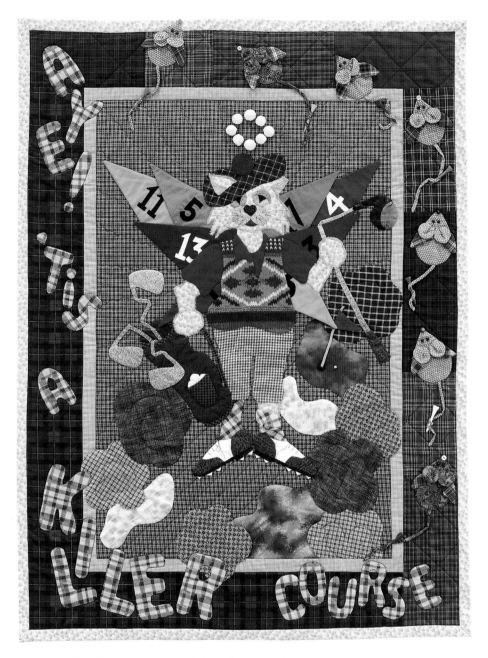

Ol' Andrew MacMeow and the Killer Course by Ruberta C. Peterson, 1997,
Culver City, California, 35" x 46½".

I knew the minute I heard about this challenge that I wanted to do a cat angel. The question was, what kind of a cat, how to draw it, and very important, "What about those wings?" I thought about this for days. The answer came to me one afternoon, when my husband came in looking rather bedraggled after a bad round of golf.

Finding just the right fabric for that sweater turned into a marathon fabric search. At long last, I found the perfect fabric on a flat-fold table. I needed a piece about 9" x 10", so I bought two yards. I didn't want to run short. . . .

—RUBERTA C. PETERSON

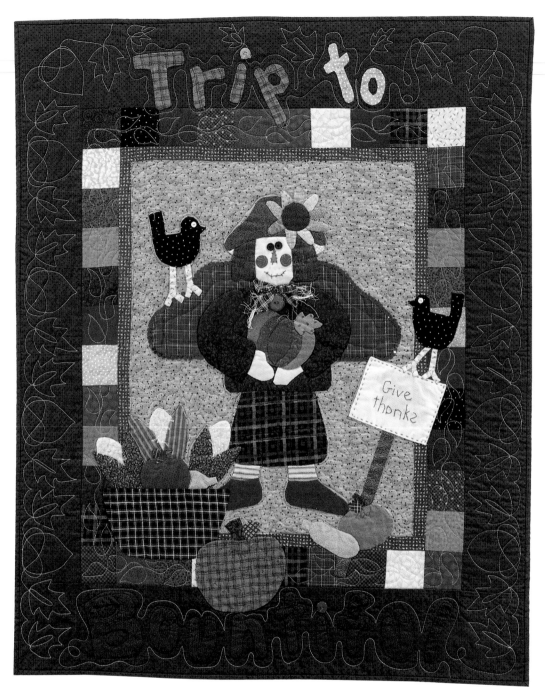

Maggie's Trip to Bountiful by Mollie Ogle Ressa, 1997, Pullman, Washington, 44½" x 58".
Quilted by Krista Bateman.

This angel looked like her name should be Maggie, and so it is. Autumn is my favorite season. The abundance of the harvest reminds us that we have many blessings for which we should be grateful.

—MOLLIE OGLE RESSA

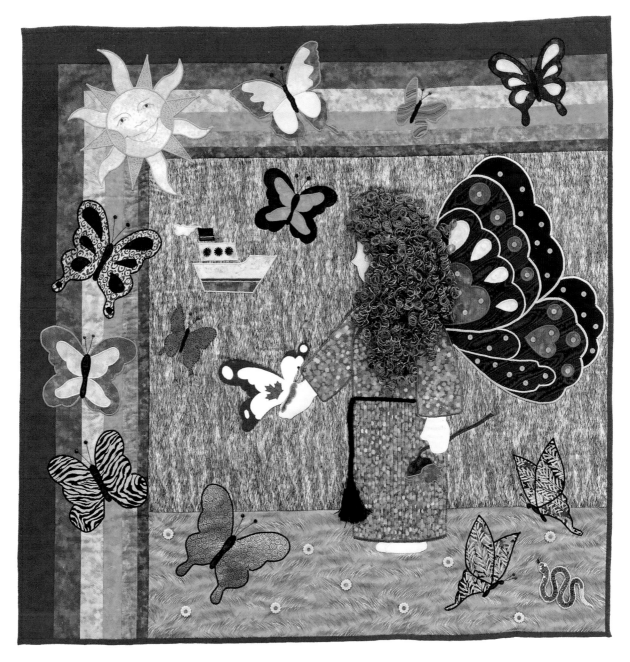

Niagara Falls Butterfly Angel by Diana Collier, 1998, Mississauga, Ontario, Canada, 40 x 39½".

This quilt is the result of a wonderful day I spent with Mary Lou at Niagara Falls. On a sunny fall day, we took a trip on the Maid of the Mist and got absolutely soaked. We both laughed ourselves silly. Later that day, we went to the butterfly conservatory and saw butterflies of every color imaginable. So, when the opportunity came to choose an angel theme, I chose to remember a wonderful day with a good friend. Memories sometimes are the most important aspects of these kinds of quilts. My sister Judi drew the body position and head for me, my friend Jeannie glued on the hair, and my friend Rita put the binding on for me. This makes it even more special to all of us.

—DIANA COLLIER

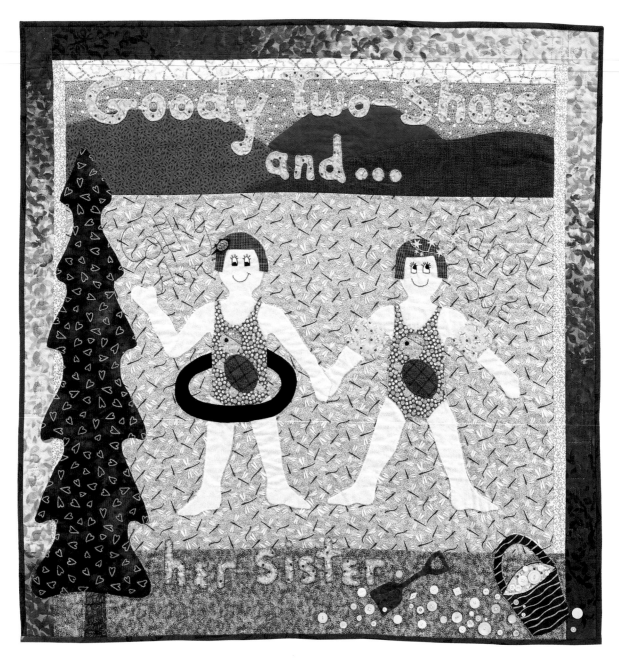

Goody Two-shoes by Cathy Lennebacker, 1998, Mukilteo, Washington, 48" x 50".

R emember when you couldn't wait to get up and put your swimsuit on? I still remember my favorite swimsuit, which featured a turtle on the tummy. My quilt portrays my identical twin sister, Carol, and me at Priest Lake, Idaho, when we were four years old. She was my best friend and playmate, but we've always been different. I couldn't stay clean, and she never got dirty. Quilted into the quilt are a few of the comments we heard: "Which one are you?" "Oh, are they twins?" and "Salt and pepper."

—CATHY LENNEBACKER

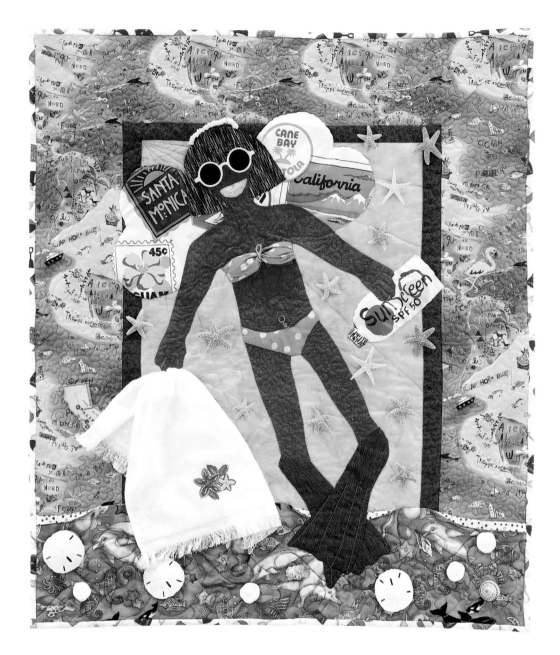

Nanette by Melody Coffey-Love, 1998, Torrance, California, 30½" x 35".

My friend Kay came over to my house very early one Saturday morning, hiding behind her sunglasses and wearing a trench coat. In her hand, she clutched a rolled-up paper. She looked around the room, then whispered "I heard from Mary Lou; she's asked us to join an angel challenge—an *angel*," she whispered.

We hit the nearest fabric store, and the fun began! I decided I wanted a beach angel. I made her skin a sunburned pink because she has no time for her own needs when she's working for the betterment of those around her. Polka dots for a bathing suit seemed just the thing (and, of course, the flamingo navel ring). When we left the fabric store, the clerk called out, "Please, come back and entertain us again!"

—MELODY COFFEY-LOVE

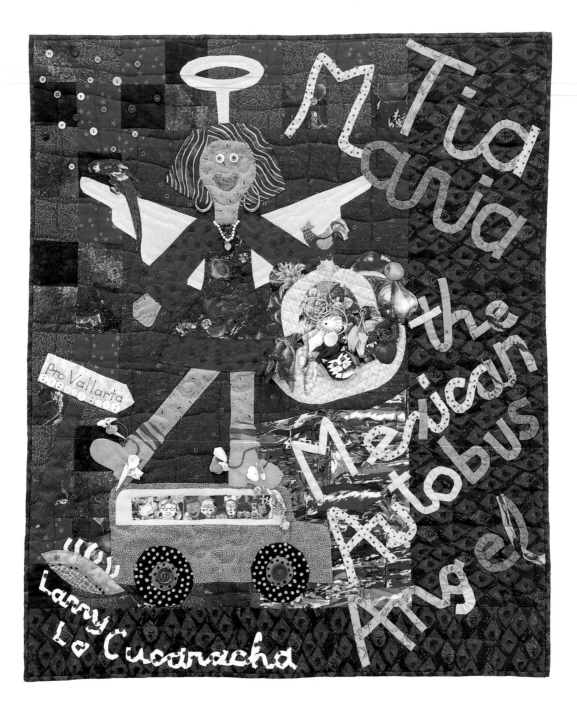

Tia Maria by Carol Scott, 1998, Spokane, Washington, 34½" x 40½".

I love sunny Mexico, so this angel seemed like a great way to remember our twenty-fifth-anniversary vacation in Puerto Vallarta. I filled this quilt with lots of color and details of what we enjoyed under the sun. You really need a guardian angel when you ride the buses down there!

—CAROL SCOTT

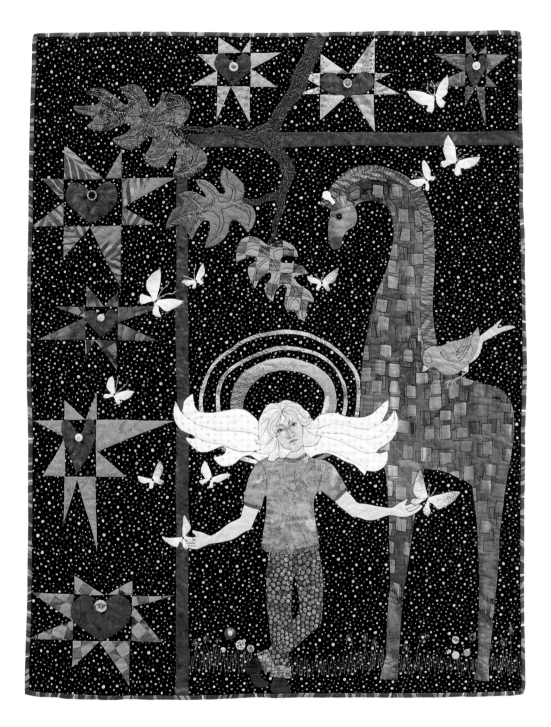

Angel Annie by Terry Waldron, 1997, Anaheim, California, 38" x 49½".

I'm a high school teacher and love art, color, and challenges. Can you tell? Once I received the angel challenge from Mary Lou, I was off and running. I enjoy making these off-beat stars and knew they would work well with an angel theme.

—TERRY WALDRON

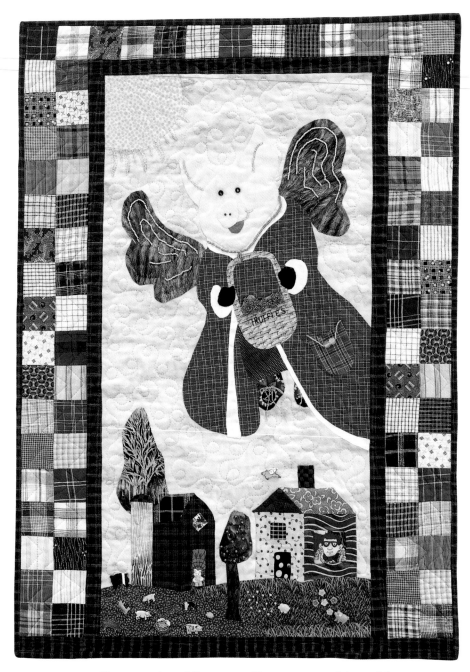

Betsy Goes to Truffle Heaven by Ardell Powers-Parkin, 1998, Couer d'Alene, Idaho, 25½" x 36". Quilted by Nona King.

When Mary Lou asked me to make an angel, it wasn't hard to figure out my theme. I love pigs! It started many years ago, when we got our first pigs to raise for the table. Finding it hard to get weaner pigs, we got a couple of sows. It didn't take long to become attached.

I started thinking that perhaps Betsy is in pig heaven, rooting out all the truffles. I'd like to think she flies over now and then to check on us. This quilt includes many of the pig buttons, pins, and stuff I collect.

—ARDELL POWERS-PARKIN

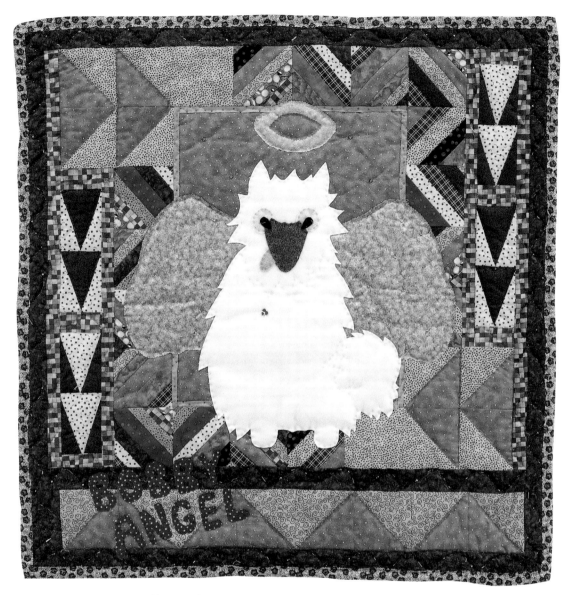

Bobby Angel by Jess McCall, 1998, Belgrade, Montana, 44" x 45".

My dog, Bobby, is the closest thing I know to an angel. When I got this challenge, I made a quilt with a dog in a jacket holding a bouquet of flowers. When I finished, I found it really didn't portray the dog our family so dearly loves. So, I started over. I think that this time, I got the true look of Bobby. Soft, fluffy, and lovable. He's our angel.

—JESS MCCALL

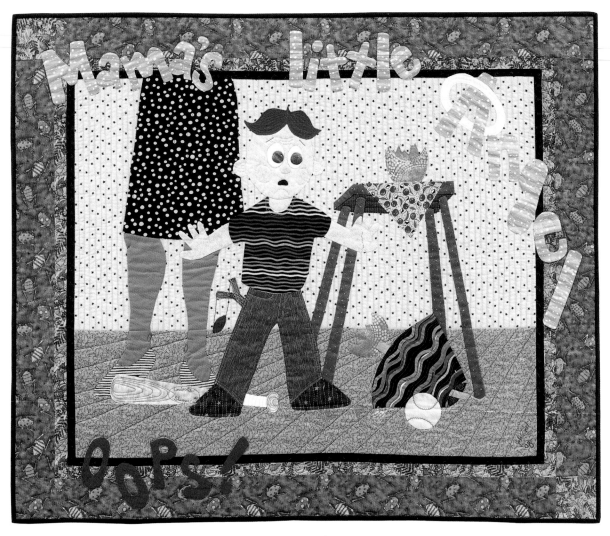

Mama's Little Angel by Julie Lynch, 1998, Greenacres, Washington, 51" x 42".

Everyone knows one, but no one ever claims one in "their family line"! Making the typical angel was too predictable and would not have been nearly as much fun. With one little phrase, three sons, and a stroke of genius from our son and designer, Casey, there was nothing left to do except appliqué the "telling" scene. A picture is worth a thousand words.

—JULIE LYNCH

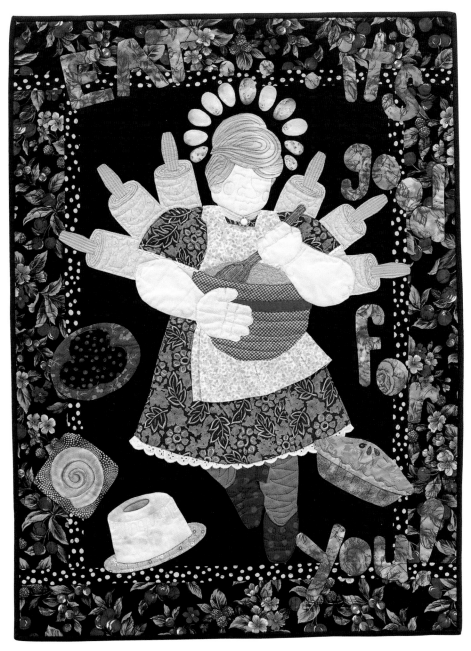

Eat … It's Good for You! by Julie Lynch, 1998, Greenacres, Washington, 33" x 44".

Can you recall dear old gram that was always baking and encouraging you to indulge? Only minutes later, in her next breath, would she remind you how chubby you were? Well, my grandma (an angel) was no different.

My angel quilt is dedicated to Grandma Beneke, who was always an angel and had only my best interest in mind. Rich and precious memories of my childhood continue to be cherished with a warmth and gentleness only a grandmother can radiate.

Our son Casey designed grandma, and the rest was up to me. The outside border holds many calories and the names of the many goodies in which we loved to indulge. The black background contains the names of those dear souls we miss so much today.

—JULIE LYNCH

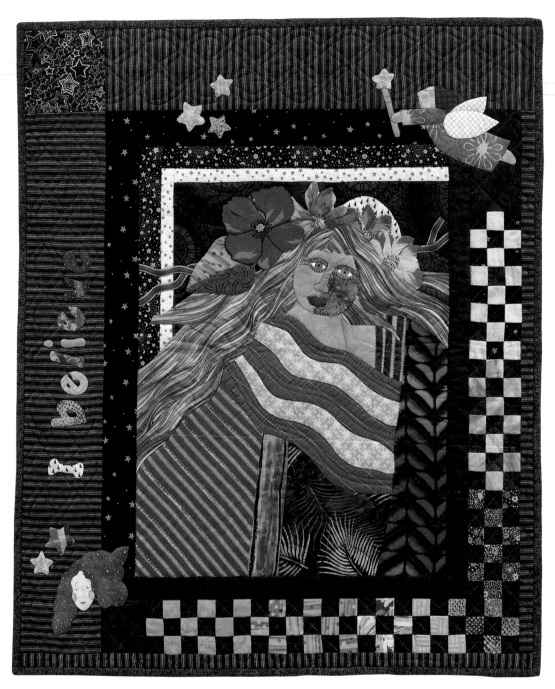

Inspiration by Eilene Hamilton, 1998, Veradale, Washington, 28" x 33½".

After I received an angel card in the mail, I decided the essence of that angel needed to be portrayed in fabric. My ideas don't always gel into fabric, but Mary Lou's angel class inspired me to make this one a reality.

—EILENE HAMILTON

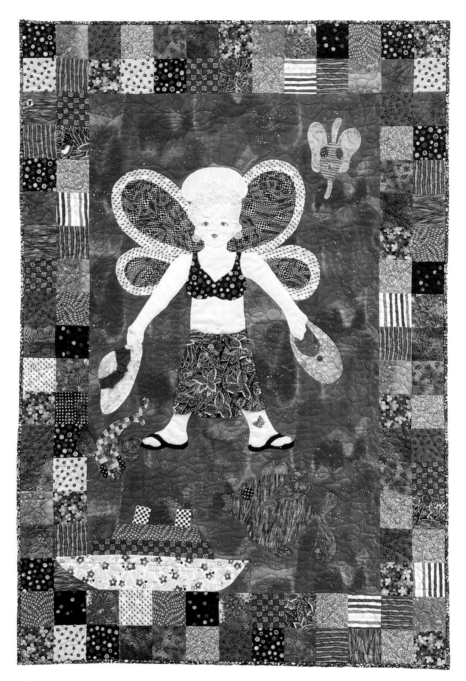

Bahama Mama, Cruise Ship Angel by Betty Bakie, 1998, Spokane, Washington, 38½" x 56½".
Machine quilting by Lorie Jones.

My husband and I have such fond memories of recent cruises that when invited to make a creative angel, I had to do "Bahama Mama." I can hear the steel drum band, the clink of hurricane glasses filled with piña coladas, and smell hamburgers cooking on the pool deck. Anyone want to do the Macarena?

—BETTY BAKIE

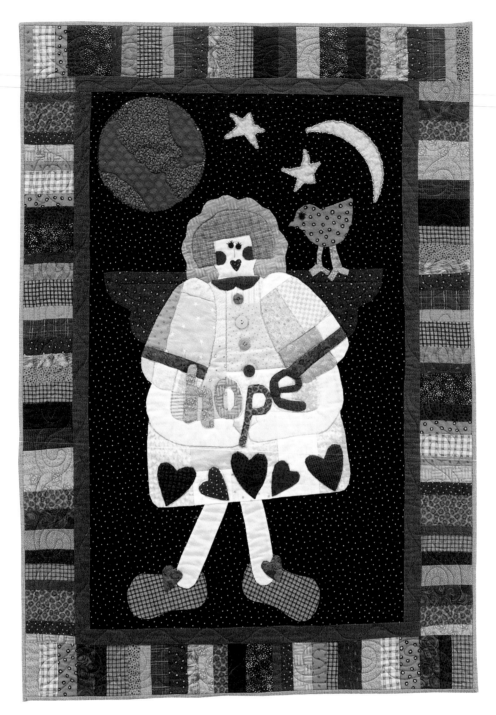

Hope for the World by Mollie Ogle Ressa, 1997, Pullman, Washington, 34" x 48".
Quilted by Krista Bateman.

started this angel in a class taught by Mary Lou. I love angels and have always known my guardian angel to be nearby. This angel offers "Hope for the World" because in spite of all the troubles in our world, there is always hope for a brighter tomorrow.

—MOLLIE OGLE RESSA

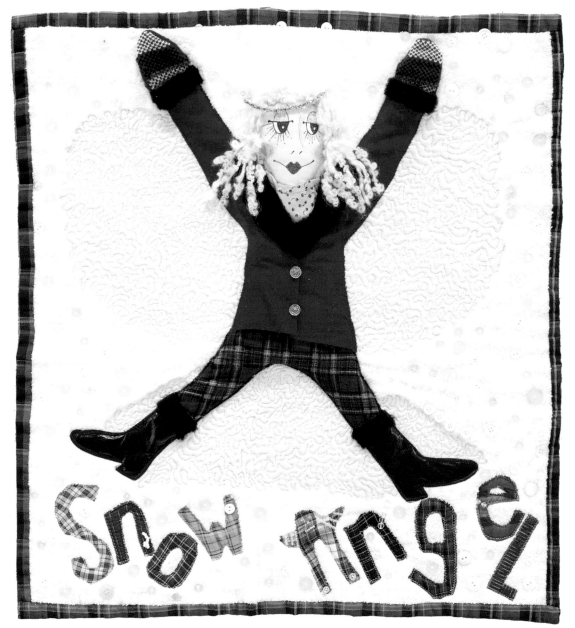

First Snow Angel by Nicole Zellmer, 1997, Long Beach, California, 29" x 30½".

Only five, so young and alive–watching her
first snow fall.
Bundled warm, she runs outside.
With her eyes open wide, she plops in the new
fallen powder.
She carefully swishes her arms and legs,
then arises to see her angel creation.

—NICOLE ZELLMER

Author's Note: *Nicole was 16 years old when she made this quilt.*

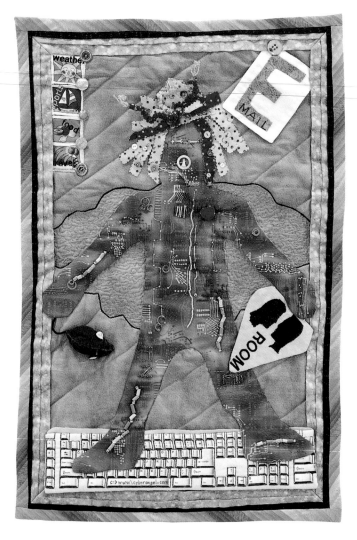

Cyber Angel by Kay Zellmer, 1997, Long Beach, California, 20" x 29".

———————————

Cyber Angel it is me,
I keep the world virus free.
You might not see me,
but I am always there,
in your e-mail, and everywhere.
I love your hard drive,
it keeps me alive.
I surf the net for the fun I get.
When you turn down the power,
I don't go away.
I keep the memory safe each day.
I'm cute, I'm fun, I'm always on the run.
I am forever yours, Chip, the Cyber Angel.

—KAY ZELLMER

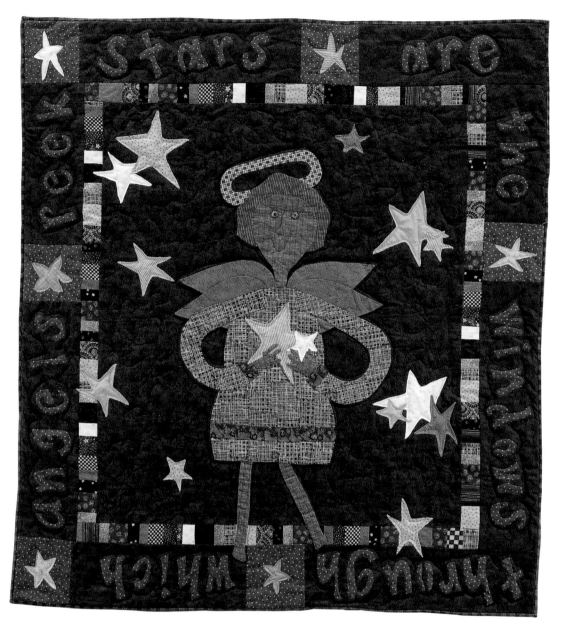

Starry Angel by Peggy Shipley, 1998, Everett, Washington, 54" x 59".

After I took Mary Lou's angel class, I was excited to see the results of my creativity (including, of course, her suggestions for purple skin and magenta hair). With Mary Lou's encouragement and guidance, this starry angel emerged nearly without effort.

Amazingly enough, I also found that I love appliqué! The large shapes made the process quite painless, and I could concentrate on how to add details, like the pieced cuffs and hem. The outer border was reverse-appliquéd (another Mary Lou–inspired technique), which went more quickly than the traditional method would have.

Finishing this project has left me enthusiastic about designing many more quilts (than I'll have time for).

—PEGGY SHIPLEY

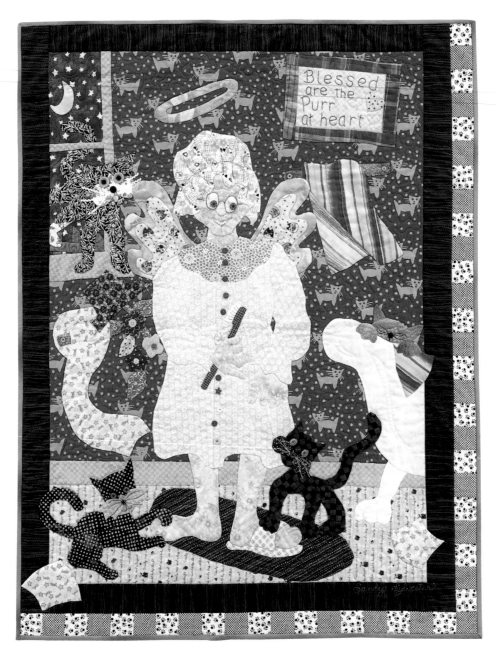

Aunt Bonnie by Sandy Sylvester, 1998, Rossmoor, California, 39½" x 51½".

When I found the saying, "Blessed are the purr at heart," I knew what angel I wanted to make! Aunt Bonnie is the assigned guardian angel for strays, even if she doesn't know it yet! Her current residents number four, but that doesn't mean any cats that might take a side trip through her yard wouldn't be welcome to share meals, family, and friends. (This usually turns out to be a permanent arrangement.)

When I found the batik fabric for the background, it reminded me of wallpaper, "purrfect" for the feline lover. Unfortunately, it reminded me of bathroom wallpaper, hence the setting!

—SANDY SYLVESTER

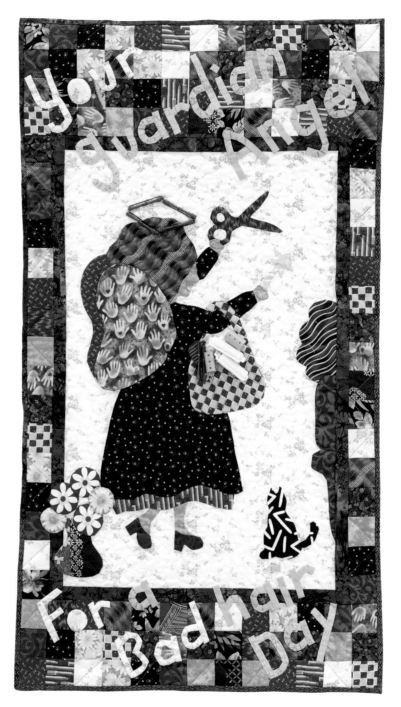

Bibbity-Bobbity Beauty Parlor by Carol Scott, 1998, Spokane, Washington, 25" x 45".

think all of us could use a beauty-shop angel at some time! Hence the theme of a beauty-shop angel on a bad hair day. Perm rods and rollers were the perfect embellishments for this quilt, which will grace my beauty shop.

—CAROL SCOTT

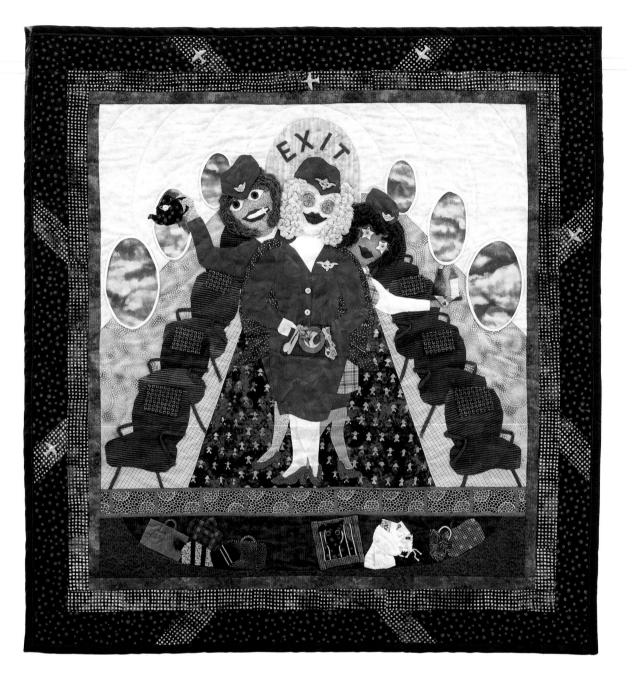

Angels in Flight by Susan Typpi, 1998, Seattle, Washington, 47" x 50".

I work with a lot of flight attendants that truly are angels, so choosing my theme was easy. The big challenge was finding fabric for the uniforms and airplane interiors. Who chooses those weird colors? I tried to portray an enjoyable story of how angelic flight attendants can be and yet not get bogged down with too many details.

—SUSAN TYPPI

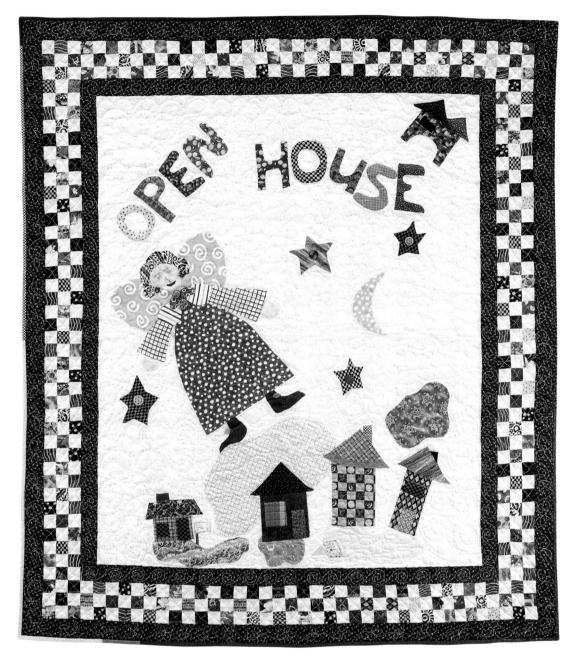

Real Estate Angel by Pam Clarke, 1998, Spokane, Washington, 60" x 68".
Designed by Michael Clarke, age ten.

My nine-year-old son, Michael, and I created this quilt on the first anniversary of my mother-in-law's death. For the theme, we chose something she loved: selling houses and having open houses. My mother-in-law owned a real-estate agency, and I still can't drive by an open house without thinking of her.

This quilt helped us get through this very difficult day. It was wonderful to talk about grandma and what she would want in her quilt.

—PAM CLARKE

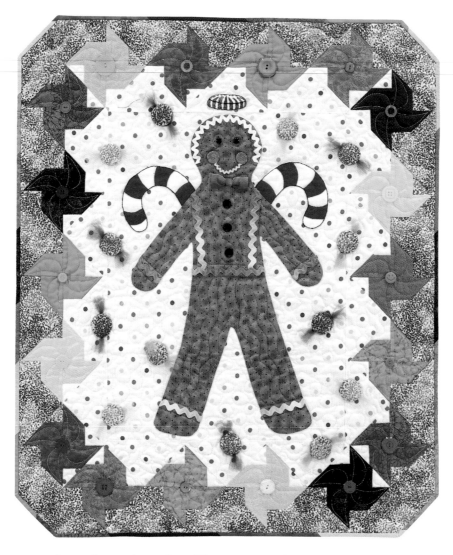

Good Enough to Eat by Candy Huddleston, 1998, Spokane, Washington, 29" x 34½".

When Mary Lou asked me to make an angel, I thought she was talking about a block. So when I opened the envelope that had been lying around for five months, I was shocked to see a full-size angel! With the holidays just over, I had sugarplums on my mind. I figured that with a small amount of modification, Mary Lou's chalk outline could become this delectable gingerbread angel.

To start, I knew I needed a light, playful background. I tried four or five backgrounds before I chose the polka dots. I also knew the icing just had to be rickrack, so when I discovered iridescent white and rainbow-colored rickrack, I was delighted. Of course, a cookie angel needs candy wings and a peppermint halo. (I painted the halo because I didn't want to appliqué those little pieces.) Not bad, I thought, but it needs some brightening up. Maybe hard candies?

To make hard candies, I double-faced circles, stuffed them with batting, then wrapped them in colored tulle. I chose a bright fabric for the border, then added pinwheels to balance the theme area with the border. After quilting with metallic thread, I embellished my quilt with buttons, the dimensional candies, and a bow tie. Thanks for the challenge, Mary Lou!

—CANDY HUDDLESTON

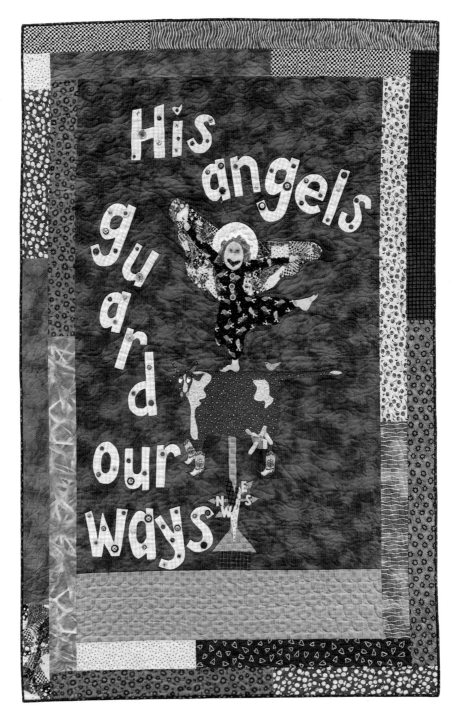

His Angels Guard Our Ways by Janet Nesbitt and Pamela L. Soliday, 1997, Reardan, Washington, 53" x 83".

As sisters and owners of a shop that is on a homestead in a rural area, we thought about the angel that must surely be looking over us. We work out of a carriage house and think of our style as warm and cozy in the country.

Hence, we have a weather vane on a barn (our shop) and our own special, beautiful angel watching (whimsically) over us.

—JANET NESBITT AND PAMELA L. SOLIDAY

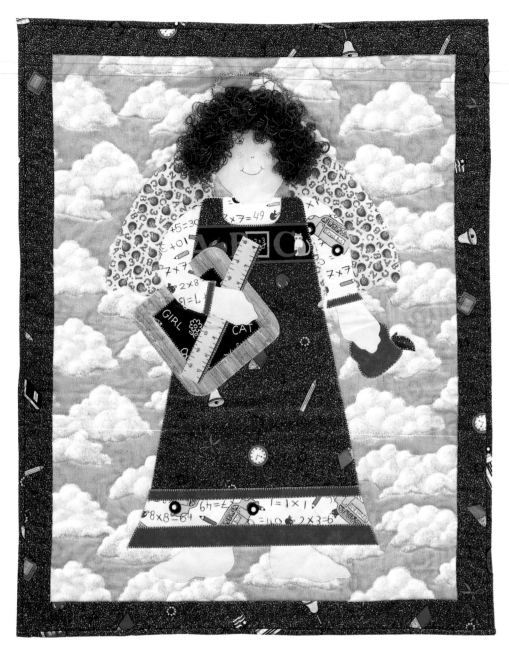

Teacher Angel by Karen Waechter, 1997, Tampa, Florida, 24" x 30".

I'm a kindergarten teacher. When I read Mary Lou's challenge, a school theme seemed obvious. I used fusible web to make the fabrics stiff so I could cut out the shapes from paper. (I guess it's all the cutting and pasting we do in kindergarten.) I included those things that are normally associated with teachers: slate, ruler, and apple. This will be fun to share with the kids in my class.

—KAREN WAECHTER

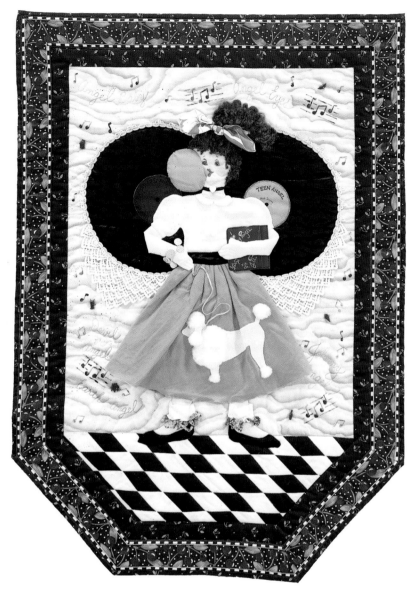

Teen Angel by Linda Hanson, 1997, Creston, Washington, 32" x 45".

I was excited and flattered to have the opportunity to join in on Mary Lou's challenge. I sketched four different design ideas, but I kept coming back to "Teen Angel." I began with a heavy decorator fabric for a heavenly mood. The cherry borders remind me of the 1950s, when my sister and hero was a teen angel.

I stuck with my 1950s theme for my angel's dress: poodle skirt, fuzzy collar, satin belt, fancy anklets, pantaloons, stiff net slips, little black patent-leather shoes, heart choker, pom-poms, charm bracelet, bubble gum, and ponytail. Of course, she carries a notebook with Johnny Angel's name.

For her wings, I used old seventy-eight records, finishing them with lace as befits an angel. My friend produced a "Teen Angel" record, plus a complete set of buttons on their original 1950s card. I used the buttons on the background and the card for my label.

I like to do original work. This design challenge was great fun, and I'm excited about sharing it through this book.

—LINDA HANSON

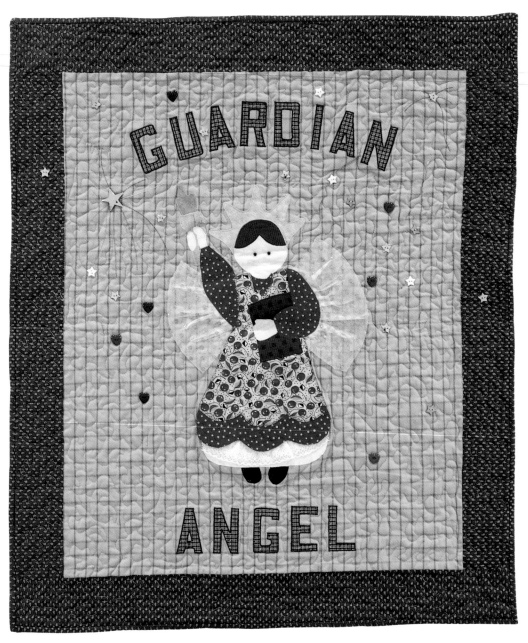

Lady Liberty by Helen Clapp, 1998, Henderson, Nevada, 35" x 41".

What can I say? I do love my country. I feel that the freedoms we all take for granted are overwhelming. Every time I hear the national anthem, I cry (which can get really embarrassing at football games). If I see the flag on a clear spring day, I tear up. To me, the Statue of Liberty is a wonderful symbol of an even more wonderful country, and she truly is our guardian angel.

Part of my goal for this quilt was to show that you don't have to hand appliqué. I made this quilt with machine stitches and a lot of love.

—HELEN CLAPP

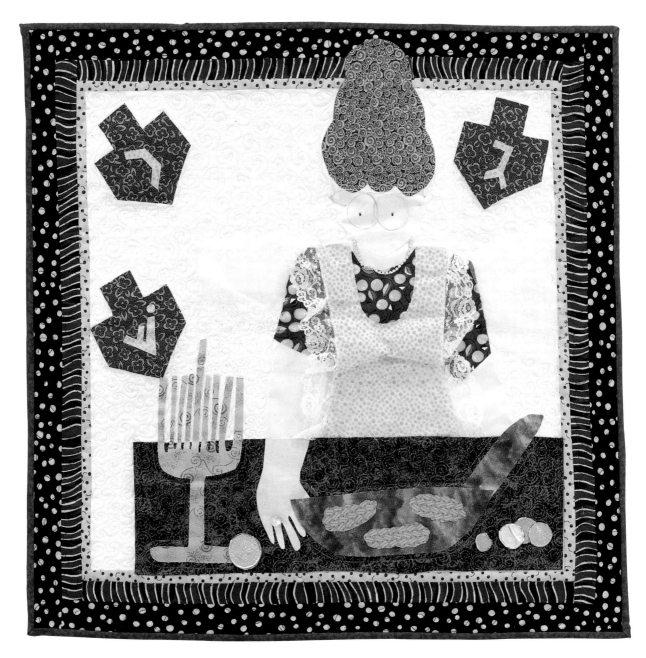

Hanukkah Angel by Leslie Huppin, 1998, Spokane, Washington, 29" x 29".

created this Hanukkah Angel with my daughters, Melissa, age ten, and Kaitlin, age eight. We agreed that Bubbe, their grandmother, had to look "together" and well dressed, even when cooking our favorite Hanukkah dinner. Of course, we had to include potato latkes, an important part of dinner; dreidels and gelt (gold coins), representing the children's games; and the menorah and candles, signifying the eight nights of Hanukkah.

—LESLIE HUPPIN

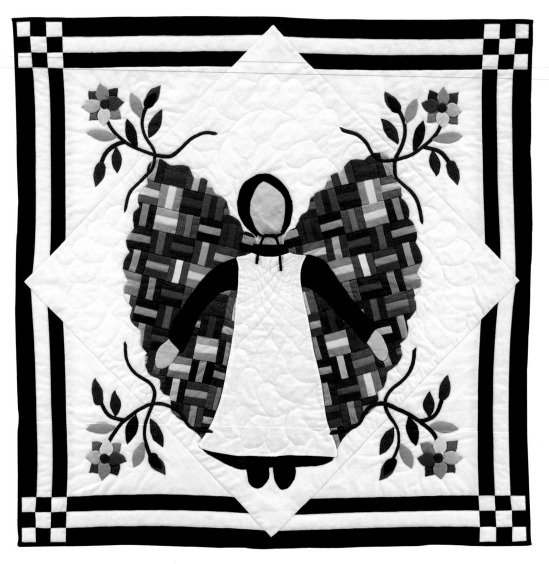

Plain and Simple by Mickey Van Pelt, 1998, Glenwood, Iowa, 34½" x 34½".

I met Mary Lou while hosting a quilting-forum chat on America Online. One night, she invited me to join her in a very special new project, which immediately piqued my interest. (I have a hard time turning down a good challenge.)

The first challenge was the theme. For the next month, I thought about themes. I wanted just the right idea, but everything that came to mind seemed too boring. At Christmas, a dear friend gave me Sue Bender's book, *Plain and Simple,* about the Amish. Wow! I wanted to create a plain, simple angel that bloomed outward into flowers, depicting my view of Amish lives, gardens, and quilts.

The next challenge began when I realized that I didn't have enough time to hand quilt. So, fifteen hours and a lot of grumbling later, I completed my first machine quilt. (My family and friends did not particularly like this part of the process.)

I enjoyed this project; it really made me think and expand my quilting abilities. And I made a new friend in the process. Thank you, Mary Lou.

—MICKEY VAN PELT

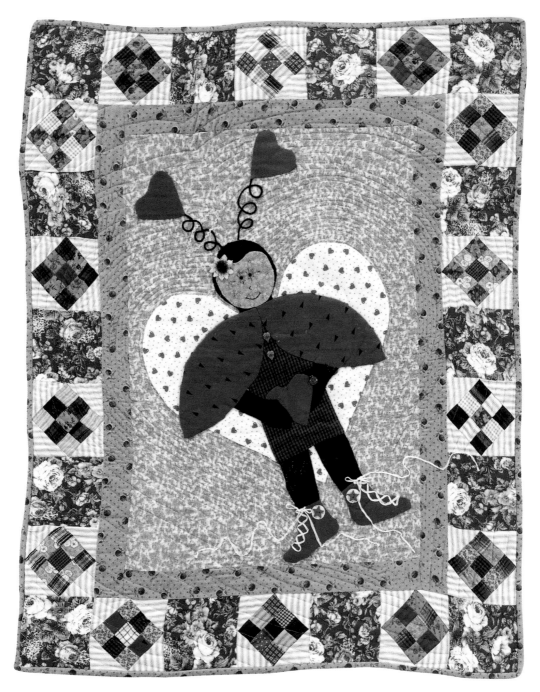

Love Bug by Barbara Saia, 1998, Morro Bay, California, 34½" x 44½".

My inspiration came from my car, a 1967 VW Beetle that is painted exactly like a ladybug and has a "love bug" license. So, the Love Bug was created!

When I draw ladybugs, I make black hearts instead of black dots. I felt that I had to have heart fabric, which is why I used flannel to make this quilt!

—BARBARA SAIA

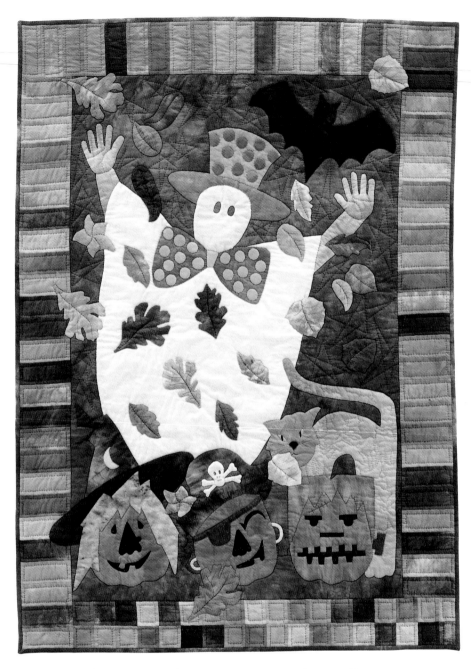

The Ghost of Halloween Past by Lynda Carswell, 1998, Belmont, California, 30½" x 42".
Partially based on pattern (Fun-Kins) by Janie Coscarelli (see "Resources" on page 85).

This is a portrait of my ten-year-old son, taken from a snapshot of last Halloween. Once upon a time, I thought he was an angel all the time. Now, I think he's an angel only when he's asleep.

I was inspired by important parts of my life: dyed fabric (I want to use the fabric I dye, rather than just fondle it), a trip to Yosemite, and last but not least, a workshop with Mary Lou. The colors and floating leaves were part of an early November trip to Yosemite.

—LYNDA CARSWELL

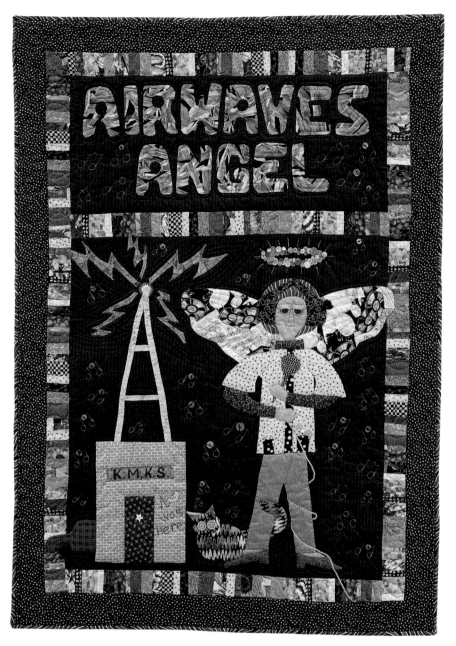

Airwaves Angel by Kathy Skomer, 1998, Greenacres, Washington, 43½" x 60½". Quilted by Wanda Jeffries.

When I signed up for Mary Lou's Creative Angel workshop, I knew we'd be making a quilt that expressed some part of ourselves. I gathered a huge selection of fabric to make an "aviary angel" that would show my love of birds.

In class, Mary Lou suggested that we make a background, then stand back and let it speak to us. It did. My thoughts of birds and angels went flying out the window. The wild jungle fabrics in the sashing reminded me of my youngest daughter's favorite colors. No pastels for her! She's a disc jockey who loves to play ice hockey. I could imagine her clothing, her cat, her little red car, and her radio station dancing across that background. It's easy to feel creative when you're as comfortable with your theme as I am with my daughter.

—KATHY SKOMER

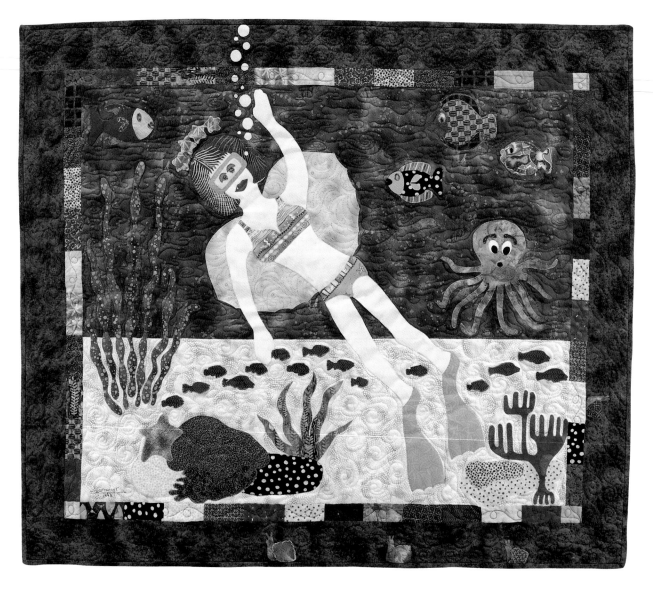

Scuba Angel by Judy Lysiak, 1998, Spokane, Washington, 51" x 43".

Scuba Angel is the guardian of all good fish and other underwater life. She also protects quilters whenever they go swimming or diving in the ocean. Occasionally, on warm, moonlit nights, you can see her swimming with porpoises and whales off the Oregon Coast near Cannon Beach. She is a distant cousin of mermaids and is responsible for bright colors in fish, not to mention she looks just like my daughter, Mignonne Jillian.

—JUDY LYSIAK

Quilt-Shop Quilts and Their Stories

Like most quilters, I love to feed my fabric monster. I never seem to have enough fabric, even though my shelves are sagging and the cupboards are full. There's always something new and wonderful at the quilt shop. Plus, I like scrappy, so I tell myself I "need" all of those cottons. This revives me so that I can go back and start another quilt. It must be working; I make about forty quilts a year.

In preparing for this book, I drew up eight little angel patterns and took them to the six quilt shops I find myself in most often. Teaching at these wonderful shops helps my fabric budget, and it's been fun getting to know the staffs and their interests. I gave each shop a set of the patterns and a challenge to create a quilt that spoke for their shop. Since I knew all of these shops had a different feel, I hoped that the quilts would all be different and wonderful. And guess what? They are!

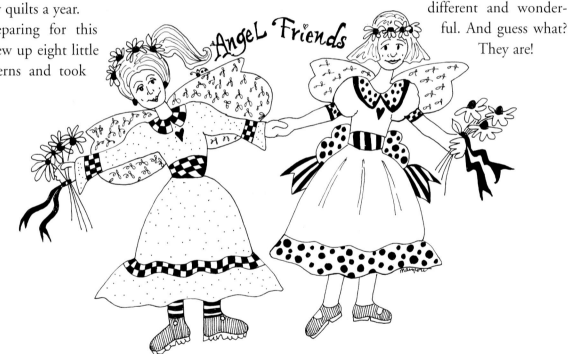

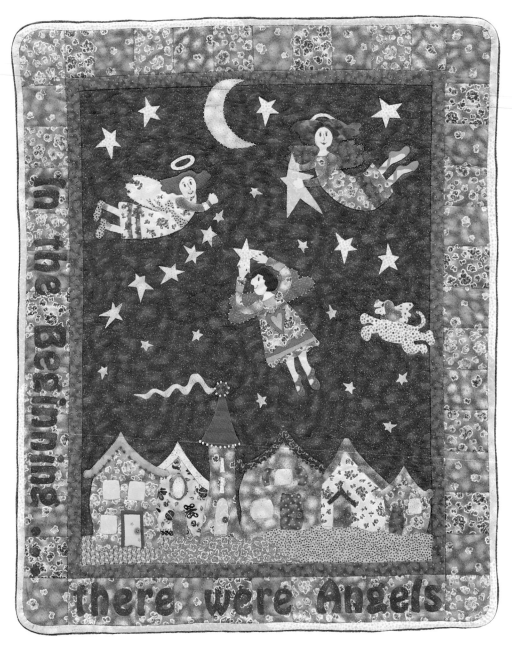

In the Beginning, There Were Angels by Kelly Hogan, 1998, Seattle, Washington, 35" x 43½".

In The Beginning, Seattle, Washington

I work at In The Beginning, one of the largest quilt shops in the United States, and when they asked me to make a quilt using Mary Lou's patterns, I chose fabric from their Quilt Retreat line, designed by Mary Lou. I used fusible appliqué and pieced the borders.

As you can see, my theme for this quilt, which features fabric angels flying over a quaint village, was "In the Beginning, there were Angels." And you know, I think there were, too.

—KELLY HOGAN

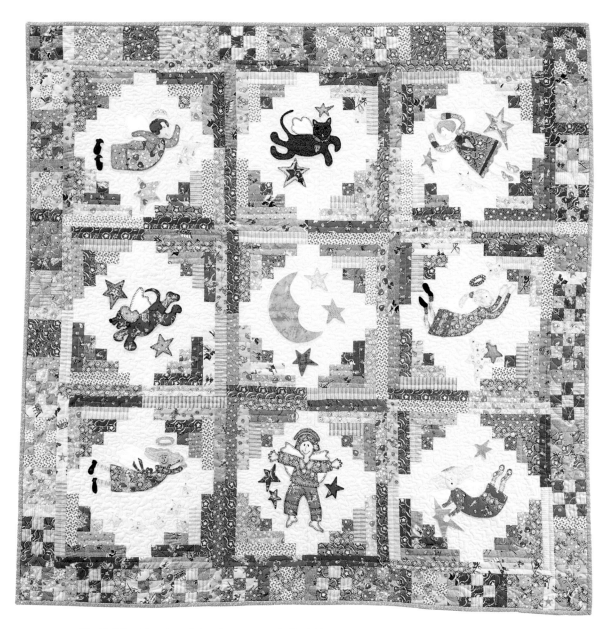

The Quilting Bee Angels by Eleanor Campbell, Vicki Dormaier, Wendy Hendricks, Manda Benton, Shirley Birch, Jackie Wolff, Carol Kline, and Carole Monahan, 1998, Spokane, Washington, 57" x 56½".
Quilted by Pam Clarke.

The Quilting Bee, Spokane, Washington

This quilt is due in part to Mary Lou and in part to a magazine article featuring top quilt shops. Eleanor Campbell designed a quilt for the magazine article just about the same time that Mary Lou approached us with her wonderful angels. So, we placed our angels on Log Cabin blocks from the magazine project. We put them together like a round robin, then let Pam Clarke work her quilting magic. Ta-da!

—JACKIE WOLFF

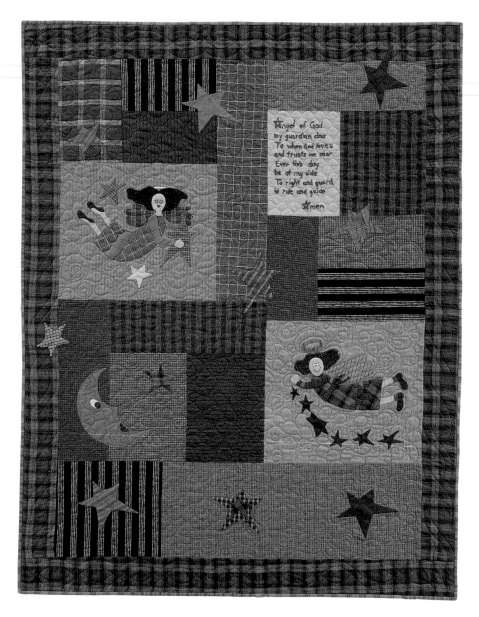

My Guardian Dear by Janet Nesbitt and Pamela L. Soliday, 1998, Reardan, Washington, 46" x 59".

The Buggy Barn, Reardan, Washington

My sister, Pam, and I own a quilt shop named "The Buggy Barn." The shop is a converted barn (it housed the buggy) on the farm where I now live.

Pam and I are sure that our angels have to do double duty, guarding us at home and here at the shop. Our theme is based on a prayer that our mother taught us, and we've taught our children: "Angel of God, my guardian dear, to whom God loves and trusts me near, ever this day be at my side, to right and guard, to rule and guide. Amen."

We chose warm country fabrics to represent our warm country shop. For embellishments, we used snaps for our angels' eyes. This quilt will have meaning to us and our children long after we are done using it in the shop.

—JANET NESBITT AND PAMELA L. SOLIDAY

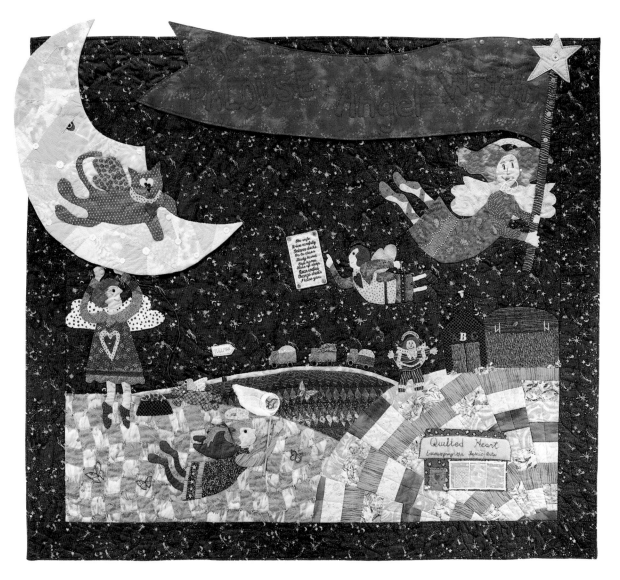

We Get By with Lots of Help from Our Friends by Debra A. McNeil, Mollie Ressa, Nancy Larson-Powers, Paulette Lowery, Susie Johnson, Brenda Cockrum, Madeline Martin, and Jack McGrath with help from our divine angels, 1998, Pullman, Washington, 84½" x 72".

The Quilted Heart, Pullman, Washington

Living on the Palouse, we have many things we can be thankful for. If you stop for just one minute during September, an angel will guide you through the rich evening smell of freshly cut wheat fields, the sight of the breathtaking harvest moon resting over the rolling hills, the sound of autumn leaves rustling beneath your feet, the feeling of anticipation and excitement as families bring their children here to attend the local state university.

Stop for just one minute to listen, and an angel will whisper to you of the friends, the sense of community, the pride of knowing that we enrich our own lives by helping others. (And if you look very carefully, you'll see the Palouse Angel Watch). Is this heaven? Absolutely!

—DEBRA A. MCNEIL

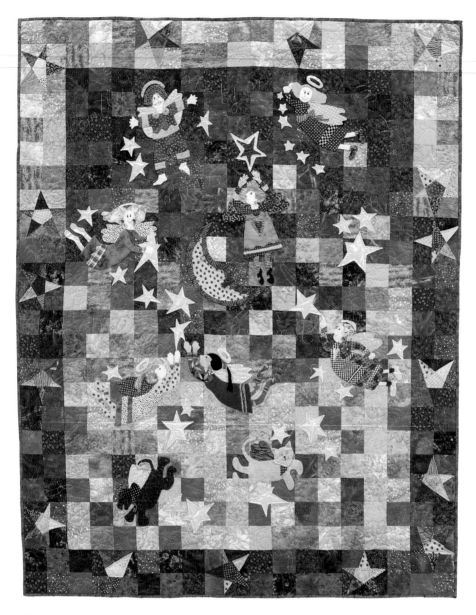

Stars, the Forget-me-nots of Angels by Barbara Lambrecht, Betty Bakie, Sandy McCauley, Nancy Gallivan, Mary Ellen Laughary, Florence Coffey, Adele Carter, Pat Means, Pat Verhei, Cheryl Poffenroth, and Larry McCauley, 1998, Spokane, Washington, 56" x 70". Quilted by Pam Clarke.

Pacific Crescent Quilting, Spokane, Washington

When we saw Mary Lou's angels, we thought that each one had its own personality and duty. We brought them together with Henry Wadsworth Longfellow's poem (stitched in the quilting):

Silently, one by one, in the infinite meadows
of heaven
Blossomed the lovely stars, the forget-me-nots of
the angels.

—SANDY MCCAULEY

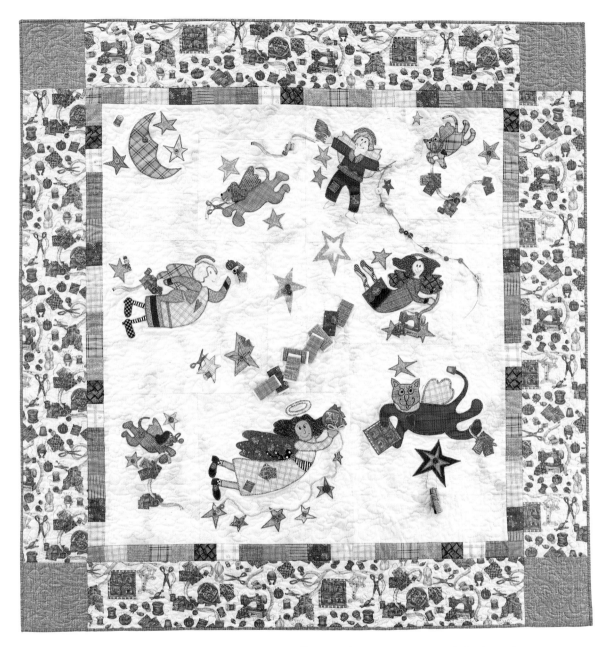

A Quilter's Notion of Heaven by Stephanie Muellhaus, Gayle Noyes, Jean Van Bockel, Arless Scheet, Deb Townsend, Betty Franzetti, 1998, Coeur d'Alene, Idaho, 42" x 47".

A Stitch in Time, Coeur d'Alene, Idaho

We put our heads together to take on the angel challenge and decided we would use plaids. After looking over our many shelves of fabrics, we found this border fabric, which had many sewing notions and a color combination we liked. We went back to our plaids and pulled fabrics off the shelf that coordinated with our theme fabric. Since the border fabric was notions, our angels needed to have sewing notions to keep them happy in heaven. Even the dog and the cat angels were turned into quilters!

—STEPHANIE MUELLHAUS

Heavenly Steps to Extraordinary Quilts

Now that you've seen a few quilts and read a few stories, you probably have ideas for your own little slice of heaven. This chapter is your step-by-step guide to designing your own angel quilt. To help you get started, I've provided a pattern for a basic angel body that you can enlarge or reduce (see pages 86–87). Jump in!

Do not forget to entertain strangers, for by so doing some people have entertained angels without knowing it.

HEBREWS 13:2

Choosing Color and Fabric

Choosing color and fabric can be intimidating when you're faced with a shop full of every color and print imaginable, but once you learn the basics of color, value, and scale, it becomes easier. Remember, every quiltmaker has his or her own style. Following are some tips that will help you develop your own sense of style.

- **Color:** I learned long ago that using a color wheel was an easy method for fail-proof color. By following a basic color formula, you can count on the colors to enhance each other. I call this "the quiltmaker's theory of relativity": any color placed next to another color is relative.

To get started, I choose a great color, such as red. I look at my color wheel, and go to the complementary color directly across the wheel—green. Then I choose one more color, either a primary or another secondary color. Let's say I pick blue, another primary color.

Next, I go shopping. I try to purchase eight to ten different fabrics in each color. Once I've selected these fabrics, I add a few neutral fabrics—honey-toned beiges, black prints and geometrics, dark or deep browns, or dark navy blue prints—for sparkle. Black and other deep, dark colors add sparkle and personality to color palettes.

I'm known for using a fabulous color I call "cheddar," which is the perfect complement to blue, purple, or turquoise. My cheddar ranges from a color that actually looks like cheddar cheese to a mustard color that has just a hint of orange. Most good cheddars are neither orange nor yellow; they're a combination that seems to give off light. Quilts with a little cheddar really pull in the eye. If you haven't tried cheddar, maybe this would be a good opportunity!

Many students ask for color suggestions when choosing their fabrics.

I think the following are marvelous color combinations. If you want to try something new, how about these?

- Red, green, blue, honey, black
- Pinks, purples, raspberries, teal
- Blues, purples, cheddars, raspberry
- Honey, browns, beiges, golds, black
- Lime greens, pinks, bright blues, neutrals
- Teal greens, dark forest greens, burnt reds, honey, black
- Dark cheddars, dark reds, medium blues, vivid violet, warm beige
- Bubblegum pinks, browns, dark reds, black, blues
- Cheddars, teals, greens, burgundy, black, warm beige

◼ **Value:** When you choose fabrics, don't forget the importance of value. The most common mistake I see in my workshops is lack of value contrast. Most quiltmakers choose mostly light fabrics, mostly medium fabrics, *or* mostly dark fabrics, instead of a range of all values. Force yourself to purchase colors in the other two value ranges.

How can you tell? Place your fabrics next to one another. If no one fabric looks lighter or darker, then you need to go back to your quilt shop! Remember, if your background is light, use medium and dark fabrics for contrast. If your background is medium or dark, use lighter fabrics.

The variety of values is what invites your eye to really look at a piece. The more value you use, the more interesting and successful your project will be.

◼ **Scale:** I try to look for fabrics that vary in scale and help tell my stories in an interesting and fun way. For example, look for fabrics that could be wings, curly hair, glowing halos, and fabulous starry skies. I like scrappy borders, so I look for theme fabrics that could be used effectively with whimsy and great color. For example, if I were doing one of my typical borders, I might include three or four different star prints, an angel-kitty print, a cloud print, and then work in the usual plaids, dots, stripes, and light-giving fabrics. This way, the theme fabrics I use would convey heaven or heavenly hosts, all the while adding great color and interest.

When you choose fabrics, look for fabrics in the following five categories.

- Stripes
- Dots, spots, and circles
- Plaids
- Graphics
- Light givers (prints with light, medium, and dark values)

Remember, the more varied your fabric, the more interesting your quilt will be.

◼ **Skin color:** We all know that angels come in all colors, but you may not realize that each one comes in more than one color. If you look at a person's face, you'll see that when the light hits it, there are many shadows of lights and darks. No person or angel is one color. So, when you choose skin fabric, choose a small print. If the print is too large or has large flowers here and there, you'll have unfortunate blobs on the face and hands. I look for small checks, tiny stripes, and tone-on-tone prints.

Remember when you were in grade school, and your teacher had you mix flesh tone using white, yellow, red, and brown paints? Do not try to make your angel that hideous color. Any other

color—including blue, maroon, cheddar, and eggplant—is wonderful.

I believe in building a fabric stash. Rather than buying any fabric that catches my eye, I look for specific things for my stash. For example, I look for circles, stripes, and wavy prints for hair. To protect my pocketbook, I limit myself to one-third-yard pieces. This way, I always have a wonderful variety of fabrics to choose from. If you wait to shop for just the right thing when you need it, the perfect fabric may be long gone. So, if you know you could use it someday, buy it.

Lastly, relax and have fun. The best way to develop and refine your sense of style is to practice. If you want, make a quilt-shop date with a friend who'll give you good advice.

Making a Background

I suggest starting with a 1- to 1½-yard piece of fabric. Take the time to lay it out and visualize an angel fitting onto the fabric. Consider what you will be sewing into your quilt story to support the theme. This will give you an idea of

what size you want to make your angel and other figures.

Making your border before you appliqué the figures is another creative way to begin your wall hanging. By doing this, you can set the color scheme and plan from the outside in. I like to work from a stack of about twenty to twenty-five fabrics in three color families. I put on a scrappy border, then I have lots of variety from which to pull my story figures. I think this works very well for whimsy, color, and interest. On the other hand, you may want to do a basic black-and-white background, which puts all the color interest in the center of the quilt.

By making your borders first, you can also sew into the borders. This incorporates the quilt and its story better in many cases. Sometimes, the border pulls the story its way and then pushes it back into the center of the quilt. This is a wonderful way of creating motion in your pieces.

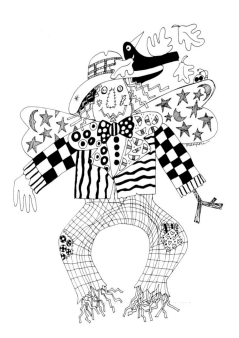

Choosing a Theme

Many quiltmakers tell me they don't know how to be creative. I've found that it's not as hard to be creative when you're given something to be creative about, along with a starting point. It's fairly simple to come up with a great angel idea once you choose a theme.

To begin, list ten different things an angel could be or do (an angel could be a policeman, a ballet teacher, a lumberjack, an opera singer). There are literally thousands of theme ideas.

From this list, choose a theme that somehow represents you or someone you love. I hope you'll try to share a bit of yourself in all your quilts. As viewers, we're interested in who the quiltmaker is, what he or she thinks is important, and his or her likes and dislikes. Think of your quilt as a statement, a diary, a piece of history. I am touched when I see these wonderful, personal

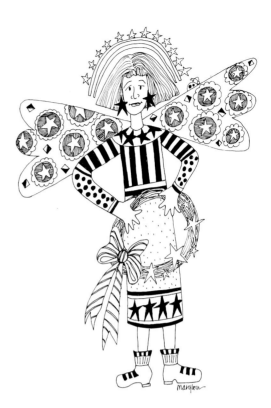

Theme Ideas

Tea-party angel	Espresso angel	Sweet-sixteen angel	Best-friend angel
Ice-cream angel	Teacher angel	Lake-cabin angel	Teddy-bear angel
Woodland angel	Fruitful angel	Fisherman angel	Skiing angel
Dentist angel	University angel	Skateboard angel	Seattle angel
Computer angel	Ticket-taker angel	Cape Cod angel	Next-door-neighbor angel
Angel fish	Frog angel	Mechanic angel	Hockey angel
Story-telling angel	Snowman angel	Disco angel	Brother angel
Farmer angel	Banana-split angel	Baby-sitting angel	Man-in-the-moon angel
Cowgirl angel	Engineer angel	Early-morning angel	Big Apple angel
Irish angel	Washington D.C. angel	Montana angel	Collectible angel
Stained-glass angel	Library angel	Berry-picking angel	Button angel
Kwanzaa angel	Shoo-fly angel	Americana angel	California angel
Ice-skating angel	Lighthouse angel	Bedtime angel	Library angel
Picnic angel	Paris angel	Midwest Angel	Garden-gate angel
Secretary angel	Ocean angel	Music angel	Bowling angel
Bird angel	North Pole angel	Shopping angel	Philadelphia angel

quilts, and I hope to encourage others to make them, too.

If you have trouble choosing a theme idea, ask yourself a few questions. What do you like? What are your favorite colors, animals, sports, foods, decorating styles, flowers, etc.? Don't be afraid to take some time to think this through!

Developing a Story

Once you've selected a theme, think about your story and its supporting props—your "quilters' clues." Sit down with a piece of paper and pencil, and write as many ideas and props as you can. Let your imagination run wild! If you feel like you need help, enlist your family members and friends. Children have great imaginations, and they may be able to outthink the adults.

While I was working on my antique angel, my daughter Shelbi suggested I include a cookie jar. Someday, she'll find this quilt in my things and remember giving me the suggestion. Including those you love is part of the pleasure and the beauty of working on these angels.

Confused? If you appliquéd a darling button angel on a background, you might have a cute

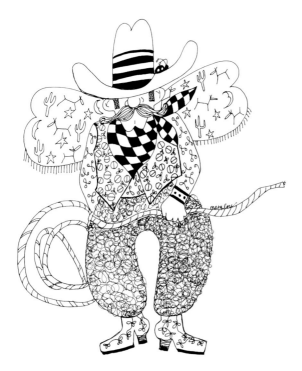

quilt. But, if you appliquéd a darling button angel on a sewing-room background, surrounded by her beloved buttons and fabrics, your cute quilt will capture the eye and imagination of your viewers. Remember, you want your viewers to recognize the theme of your quilt at a glance.

If you're having trouble visualizing a theme and props for your angel, think of your angel as a paper doll. She or he needs something to wear, a halo, and something to hold. Write down everything you can think of. Remember, being creative takes practice, and the more you practice, the more creative your ideas will be.

If you really want help, review the following story themes and ideas. Hopefully, these will lead you off in your own direction. We're all different, and our angels should suit our lives and tastes. So, give yourself some time to sit and think about these themes, and keep a notebook handy to jot down ideas that pop into your head.

◘ **Outdoor angel:** trees, tents, outhouses, shovels, rakes, campfires, bugs, camp songs, mountains, hiking sticks, wild flowers, squirrels, deer, moose, elk, fishing poles, fish, birds, bird nests, hiking-trail signs, backpacks, hiking boots, hats, vests, hiking socks, suspenders, shorts

◘ **Cowboy angel:** horse, cactus, bedroll, fence, rooster or prairie chicken, tin cup and coffee pot, "wanted" poster, boots, stirrups, wagon, rope, cow, wild flowers, coyote, western shirt, vest, blue jeans, bolo tie, hat, gloves

◘ **Christmas angel:** Christmas tree, bells, stars, wreaths, Nativity scene, candy canes, Santas, lights on strings, sayings of the season, fruits, horns, angelic white robes, tassels, fancy dresses and shoes with stars or buttons

◘ **Quilting angel:** scissors, sewing machines, pin holders, quilt magazines, quilted dolls, teddy bears, tables with quilting items, a chair made of quilted pieces, quilts all around, safety pins,

buttons, pieced or appliquéd dresses and wings, wonderful hats filled to the brim with quilting items

■ **Beach angel:** flippers, umbrella, sun lotion, beach ball, seashells, sand castle, flag, boats, sails, water, sunglasses, snorkel, pail and shovel, picnic basket, fish, bottle with note, bathing suit, sundress, sun hat, shorts, sandals

■ **School girl or boy angel:** alphabet, apple, books, lunch box, Scottie dog, pencils, paint set, bell, dresses or skirts and blouses for girls, pants and plaid shirt for boys

■ **Kitchen angel:** bowls, fruits, vegetables, bread, spoons, cookies, cookbooks, cakes, coffee pot, cups, forks, vases of flowers, pitchers, tea towels, apron, blouse with collar, skirt or dress

■ **Kitty angel:** bell, mouse, milk bottle, container of catnip, fish, a bowl of milk, cat bed, dress with fish print, heart halo

■ **Housekeeping angel:** broom, spray bottles, rags, magazines, baskets of items, dusters, kitty, dog, bird in cage, hair in rollers for halo,

housecoat and fluffy slippers, jeans, man's shirt, sneakers

■ **Attic angel:** antique trunk, hobbyhorse, wreaths, hats, button jar, cobwebs, toy truck, dolly, long gown, droopy wings, laces and ribbons for embellishing, slippers with beads, anything Victorian

■ **Baseball angel:** balls, bats, bench, gloves, popcorn, water jug, paper program, scoreboard, coach notes, bases, umpire, park scenery, baseball uniform or jeans and jerseys with hats, umpire uniforms, catcher's chest protector, baseball shoes

■ **Yankee-doodle-dandy angel:** flags, stars, bicycle, parade, rockets, wagons, firecrackers, USA, pony or horse, great jacket, tall hat, beard, bow tie, long striped pants, socks with stars, colorful shoes, cuff under jacket with star cuff links

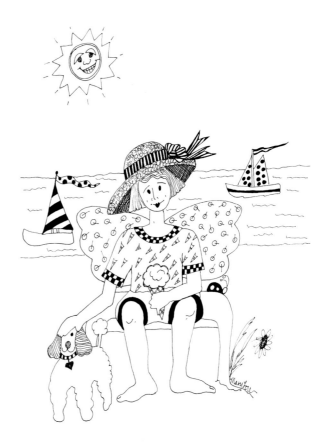

Positioning Your Angel

Often, when adults draw or execute any type of art, including quilts, they forget a very important fact: we all have elbows, knees, and waists. The good thing about having joints is that we can bend and stretch and reach. So, I would like to suggest that when you are doodling your ideas, try to think of a way to position your angel that might be more interesting than just standing with her arms at her side.

Think of the infinite ways we move our bodies. An angel could do as much or more. An angel could reach up to the stars. An angel could bend down to touch a child or pick a flower. An angel could dance and jump up and down. An angel could take a nap. An angel could read a magazine. Can you see how much more interesting this might be than an angel just standing there?

Likewise, don't forget the head. Our head position often expresses the direction we're going and the way we really feel. A head looks up, down, and from side to side. A chin can rest on fingers or a hand. A tilted head may look puzzled. The back of a hand across a forehead may suggest that someone is shocked or about to faint. Think about all of the ways heads suggest the condition of the person.

If you are stumped on positioning your angel, there are several things you can do:

■ Buy an artist's mannequin at an art-supply store. These are not expensive, and it's great fun to bend them about. This might give you a whole new theme idea: try a linebacker's stance, a ballet dancer's pose, or an Egyptian's pyramid pose.

■ Ask a family member to pose for you. I often do this with whoever happens to walk by when I'm doodling. Sometimes you are just not sure about that arm position. You can always tell them you are turning them into an angel. That should get their interest.

■ If you really don't want to draw, stick figures work well.

■ Visit your local library. Coloring books, magazines, newspapers, and children's books are great resources for body positions.

Also, don't forget the budding artist(s) in your family. If you have someone that likes to draw, why not ask him or her to help you out with your ideas? That way, they are interested in what you are doing as well.

This may be a good time to really look at how people walk, sit, and bend. I spend a lot of time in airports, and I often watch the ways people move. It's amazing to see the infinite ways we can move by bending and reaching. Next time you are standing in line, sitting at an airport, or waiting for a traffic light, look at the people around you. It's really interesting, and it helps pass the time in a productive and fun way.

Dressing for Success

One of the best parts of making an angel quilt is imagining what your angel might wear. Will your angel wear an apron or a coat? How about a uniform? There are so many possibilities. How many people can you visualize in your daily life that could be an angel? Think about the many different ways they dress. Fashion is simply another opportunity to have fun creating your unique example of who you are and what you can imagine.

Don't forget to accessorize. The well-dressed angel would have wonderful shoes. How about a purse or backpack? What about that halo? Would your angel have a traditional halo, an interesting hairdo, a velvet cloche, or a baseball hat? Need ideas? Look through fashion catalogs and magazines.

When I teach this as a workshop, I suggest two approaches to dressing your angel:

1. Tape a copy of your angel-body pattern to a window, then tape a blank sheet of drawing or freezer paper on top. Using a pencil, draw clothing—dress or shirt and pants, shoes, mittens, hats, hairstyles, etc.—on the top sheet of paper. This will be your basic dress pattern. If you want to add a vest or belt, tape another piece of paper over the dress pattern. (Don't forget the collar and cuffs!) Lastly, tape another piece of paper over the angel and draw wings and a halo.

2. If your angel will wear a dress, long sleeves, or pants and a jacket, you don't have to draw an entire body. You could start by drawing a dress, then add the head, neck, arms, hands, legs, and feet. Sketch out your ideas on paper, then make a pattern.

For more ideas, look at my examples on pages 73–77. See what wonderful ideas you can come up with.

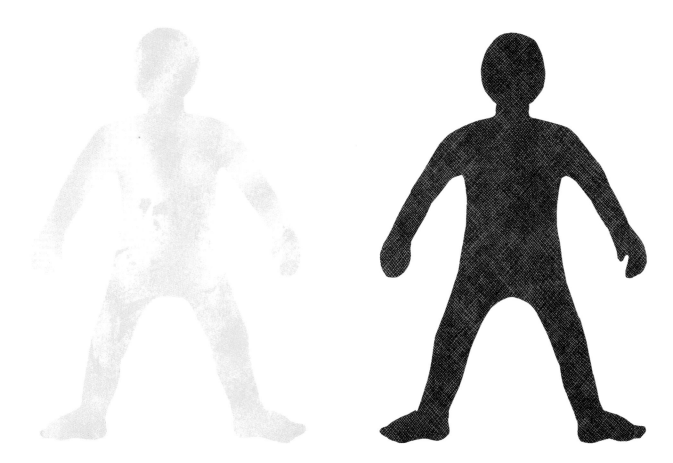

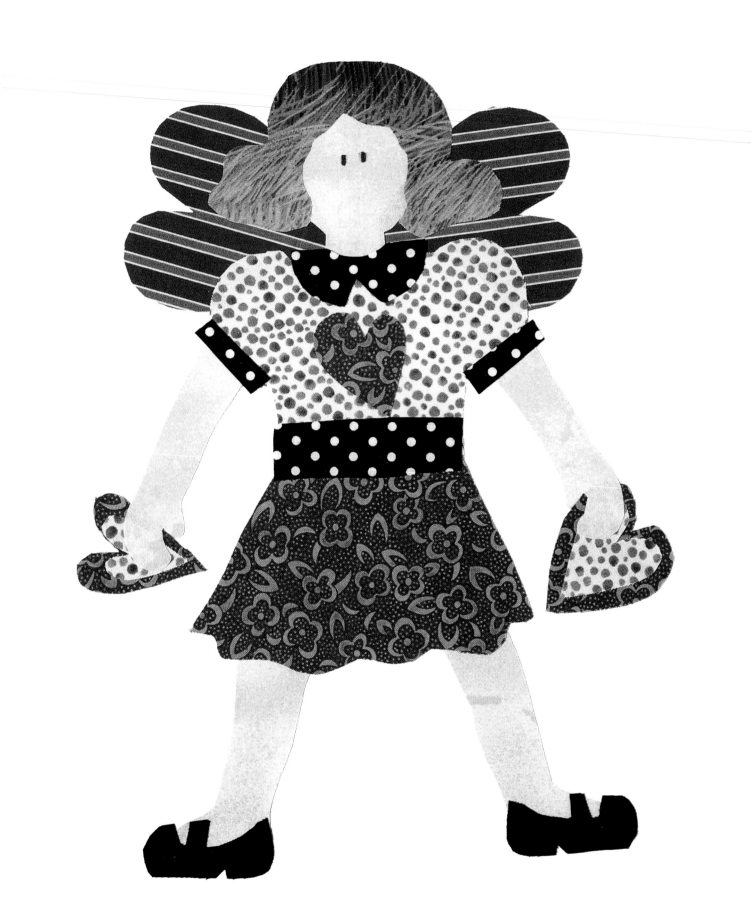

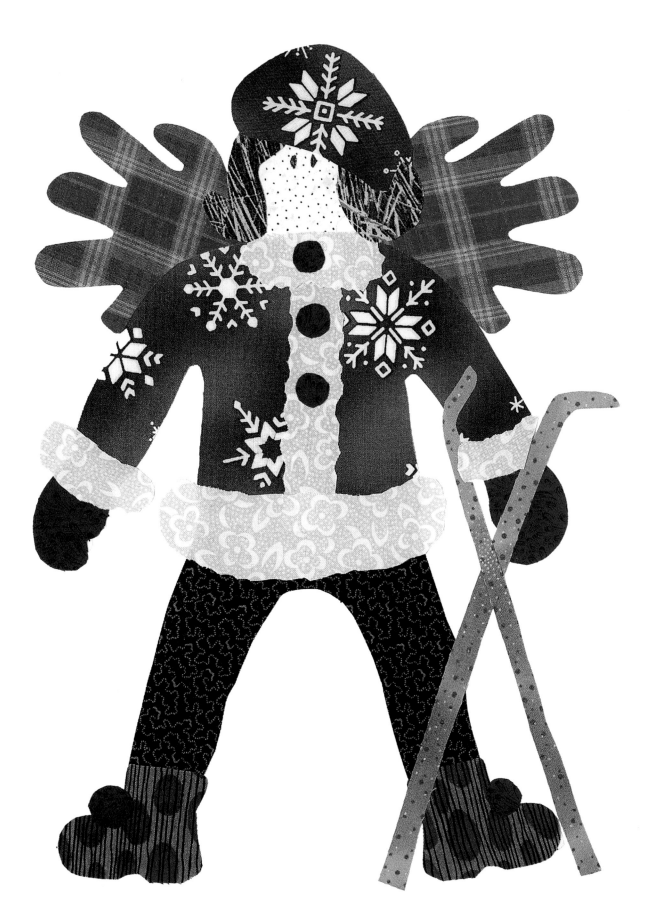

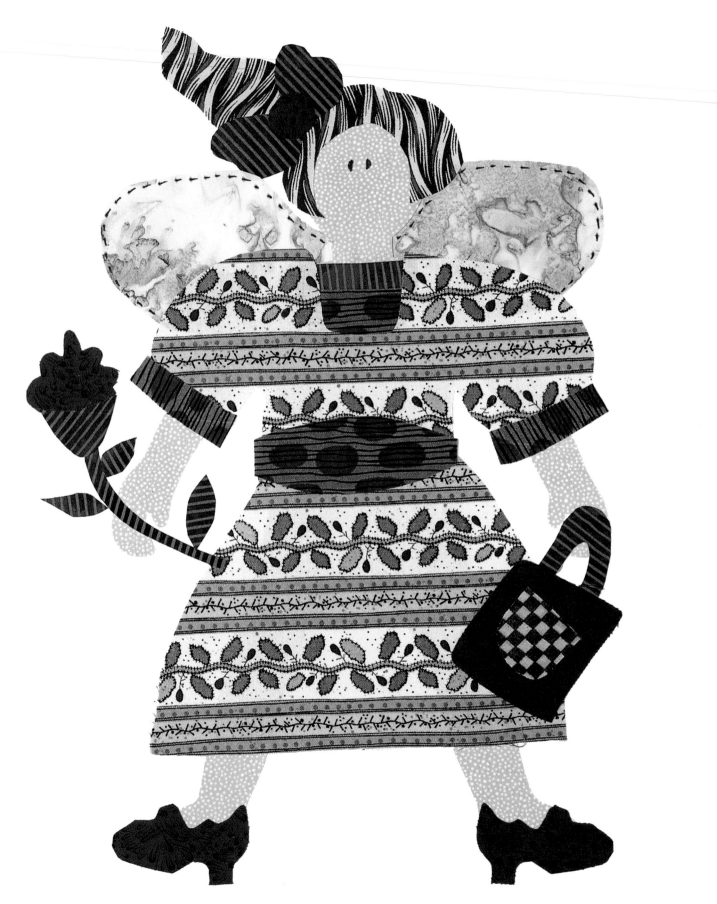

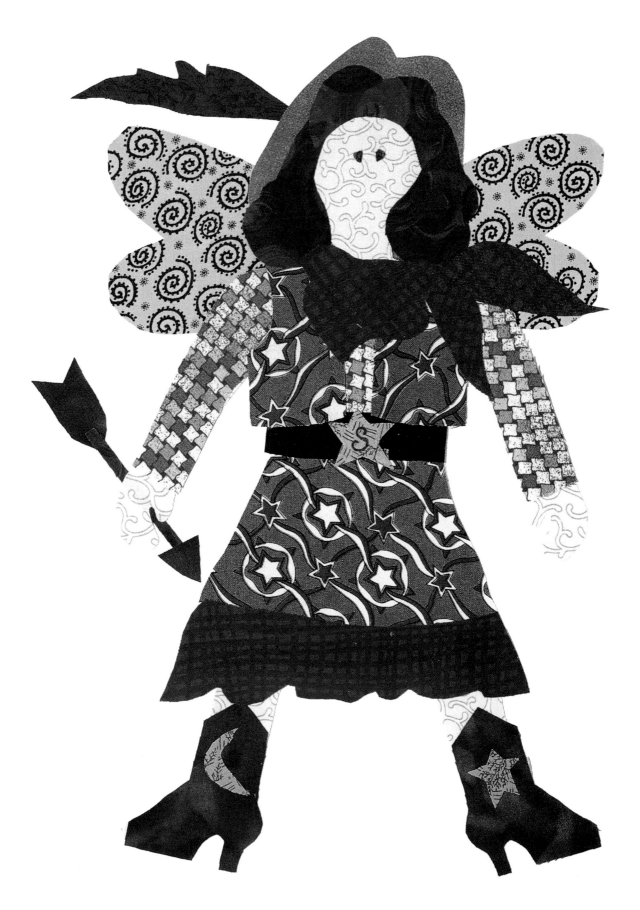

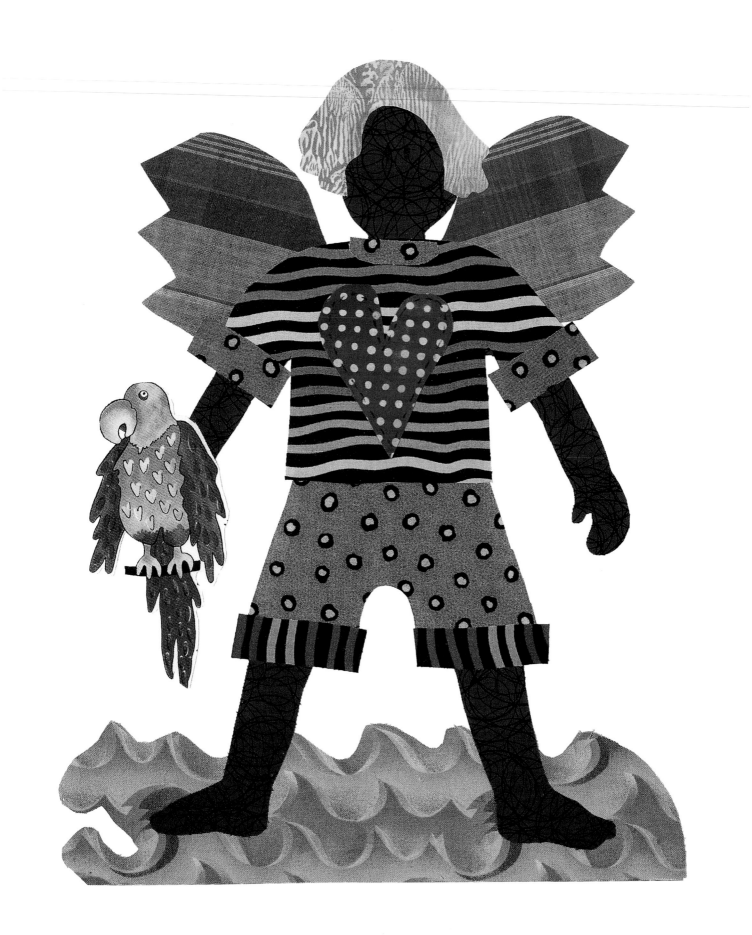

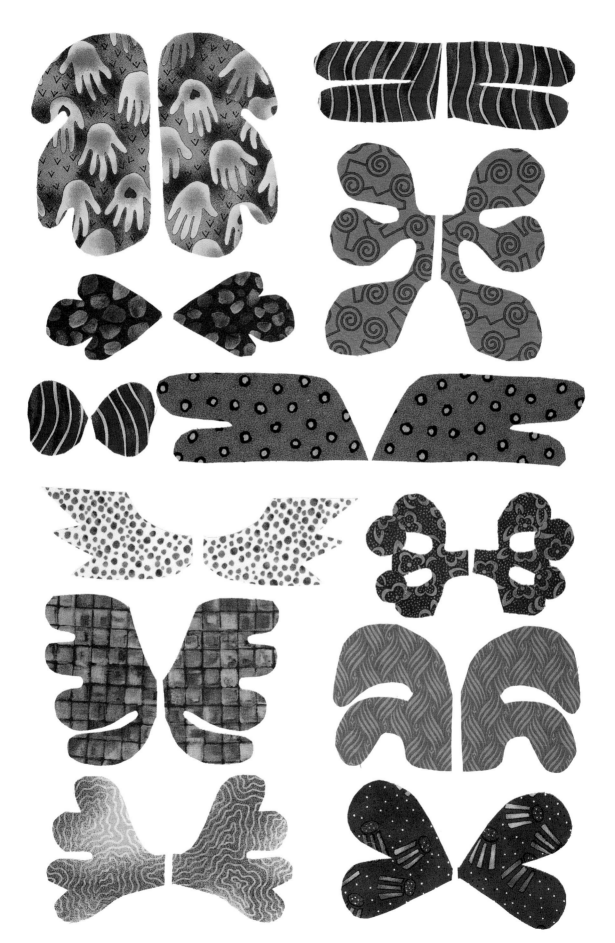

Fabricating Wings

Remember that angels fly because they take themselves lightly. Keep this thought in mind when you are designing wings for your angel. Angel wings are a perfect opportunity to get creative! Most people think of angel wings as looking pretty much like bird wings. But look at the shapes below; wings can be any shape or item that supports your theme! Wings can even be books, trees, animals, a picket fence with flowers, flags, watermelons, kitties, tools, fruit, patchwork—anything your wonderful imagination can conjure up. Don't be afraid to experiment. The more you stretch your imagination, the more interesting your quilts will be.

Just a reminder: have fun with color. It doesn't matter what color your wings are, as long as you have good contrast between the wings and the background and/or the angel body.

To make wings, I cut a rectangle large enough for both wings. I press the fabric or patchwork, then fold it in half and cut out the wing shapes as you'd cut out a heart. I pin the wings on my background, then position and pin the angel body and details for appliqué.

For ideas, look at my examples on page 78.

Say Something

Words are a powerful tool that can be used in any form of artwork, quilts included. Do you have something to say that supports your theme or tells a story? Does your angel have something to say? It's worth the time to put in a word that will provoke a thought or emotion. Quotations, Bible verses, and thoughts about your own special angel could provide a good basis for words on your quilt.

I have several favorite methods for adding letters. All are fairly simple, but they take a bit of patience. Just take your time and enjoy the process. This is part of the joy of putting words into quilts.

STRIPPY LETTERS

These easy-to-make strips are perfect for letters, bird legs, chimneys, trims, and loads of other things.

1. Purchase a ½- yard sheet of Teflon. Fold the sheet in half, then pin the corners and sides to your ironing board cover. The Teflon protects your ironing board cover.

2. Place a straight pin in the Teflon as shown. Now, bring the pin ½" into the Teflon and pin into the board again to secure.

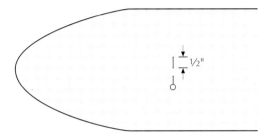

3. The maximum strip width is the width of your pin. As an example, cut a 1½" x 22" fabric strip on the straight of grain. (This is not a good method for bias strips, which might stretch and distort.) Dampen or spray the fabric strip with water, then place the strip, right side down, on your Teflon pressing surface.

4. Fold both edges to the middle and tuck the strip under the pin as shown.

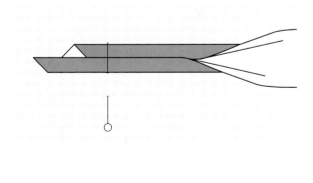

5. Press the end, then pull the strip through the pin while pressing with the iron as shown.

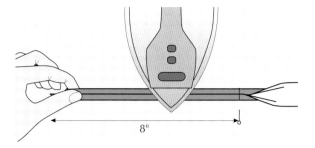

Once your strips are completed, fold the edges of the letter with your finger and tack down with a needle and thread before you appliqué the entire letter.

PIECED LETTERS

Many quiltmakers prefer piecing to appliqué. If you want to piece your letters, you can find a pattern or book, or graph and paper-piece your own design. Pieced letters are attractive and fun, but not as freewheeling as appliquéd letters.

APPLIQUÉ LETTERS

Needle-turn Appliqué: I still think traditional needle-turn appliqué is the easiest appliqué technique for letters. I draw or trace my letters on freezer paper, cut them out, then iron them on the right side of my fabric. Next, I cut out the letters, leaving a ¼"-wide seam allowance for appliqué. I clip around the curves, remove the paper, baste them to my background, and finally, appliqué them.

Reverse Appliqué: This technique is fun and works especially well for script or curved letters. If you want to add some excitement to a plain border fabric, piece the letter fabric. To begin, trace or draw letters on your background. (I use chalk.) Next, baste the letter fabric behind your background. From the background fabric, cut a small section (about 3") of one letter, leaving a ¼"-wide seam allowance. Clip the curves, turn under the seam allowance, and appliqué before moving to the next small section.

NOTE: *Remember that letters such as* B, O, *and* P *have centers that you will need to sew on later.*

Fabric Pens and Markers: I often use permanent fabric pens and markers to add words, sayings, and details. They're quick, easy, and colorfast. Be sure to back your fabric with freezer paper before writing.

Rubber Stamps: The selection of rubber stamps available at rubber-stamping, art-supply, and crafts stores is amazing. Many of these stamps, stamp inks, and stamp paints were designed specifically for use with fabric. For best results, clean your stamp after each use! Once the lettering is dry, press the fabric to set the fabric ink or paint.

These are just a few techniques for lettering. You may want to try machine or hand embroidery, stenciling, cyanotype fabric, or broderie perse. All of these techniques work well. For a more subtle message, stitch your thoughts in quilting. If you want the lettering to stand out, use a heavier thread, such as perle cotton.

Remember, angels are messengers. They may be hoping you'll share their messages.

Bordering on Heavenly

Borders frame and connect your design, much like a mat and frame. In fact, a mat and frame is a good analogy for quilt borders and binding. Your eye needs a place to stop, then re-enter the picture. If you don't border your quilt, your eye views the strength of the central design, then runs right off the edge.

Remember that you don't have to make a complicated pieced or appliquéd border for a successful folk art quilt, but you should make a border that complements and visually contains your design.

Embellishing Your Angel

I love embellishments, and I look for them *everywhere*. Embellishments can make an ordinary quilt truly extraordinary by adding texture, color, and interest. Just remember that embellishments are a highlight to draw in the eye (the icing on the cake); they're not meant to be the entire story.

Need ideas? I have had students embellish quilts with Scout merit badges, Christmas ornaments, pins, handmade lace, christening gowns, raffia, awards, jewelry, buttons, cameos, rickrack, snaps, uniform patches, hankies, charms, and photo transfers, to name just a few. Beads are a great way to add sparkle to an angel's dress, halo, and wings. You are limited only by your imagination and your pocketbook!

Meet the Author

Mary Lou Weidman was taught to quilt by her maternal grandmother at an early age; her other grandmother quilted, too. After she was grown and married, Mary Lou began making quilts for her home, starting in 1974. After years of filling beds, walls, and tables with quilts, she developed her unique folk style of quilt storytelling. She now makes about forty quilts per year, centering her themes around family, friends, and the places and things in her life that amuse and touch her heart.

Besides making quilts, Mary Lou also designs fabric, including three lines of fabric for In The Beginning Manufacturing. Color, stories, and whimsical figures are the themes she likes to include in her fabric.

In 1997, Mary Lou started her own pattern company, Mary Lou & Company, and the designs for these patterns follow the same colorful themes that her quilts do. Sentiment, whimsy, friendship, home, and family are all common threads in these patterns.

Mary Lou travels extensively in the United States and Canada, teaching others to create their own special story quilts. She likes to tell her students, "Every event in life is a quilt waiting to happen."

Mary Lou lives in Spokane, Washington, with her husband of twenty-eight years, Mark, and their daughter Shelbi, who attends a local college. Their older daughter, Shari, lives in Alberta, Canada, with husband Mark, and their son, Jason, lives close enough to stop for dinner now and then.

See, J am sending an angel ahead of you to guard you along the way . . .

EXODUS 23:20

Further Reading

An Angel a Week. New York: Ballantine Books, 1992.

Downes, Belinda. *Every Little Angel's Handbook.* New York: Penguin Books, 1997.

Stiles, Eugene. *A Small Book of Angels.* San Francisco: Pomegranate Artbooks, 1996.

Resources

Patterns

Beautiful Publications, LLC
Hari Walner
13340 Harrison Street
Thornton, Colorado 80241-1403
Young Oak quilting design

Mary Lou & Company
9116 East Sprague, Suite 42
Spokane, WA 99206
Patterns by Mary Lou Weidman

¼ Inch Designs
Janie Coscarelli
39167 Silktree Drive
Murrieta, California 92563
Fun-Kins pattern

Embellishments

JHB International Buttons
1955 South Quince Street
Denver, Colorado 80231

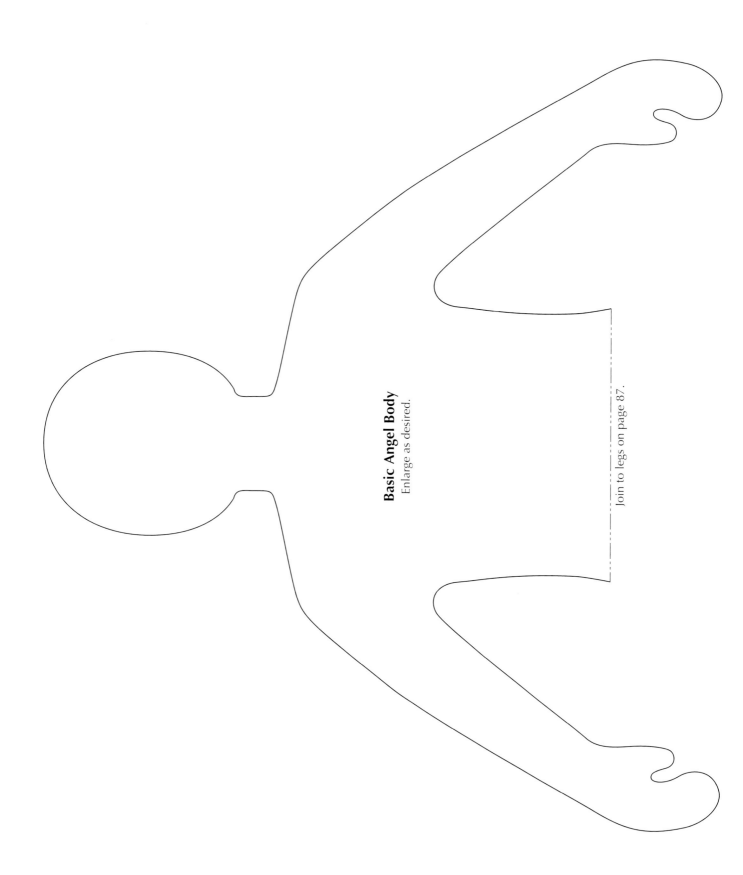

Basic Angel Body
Enlarge as desired.

Join to legs on page 87.

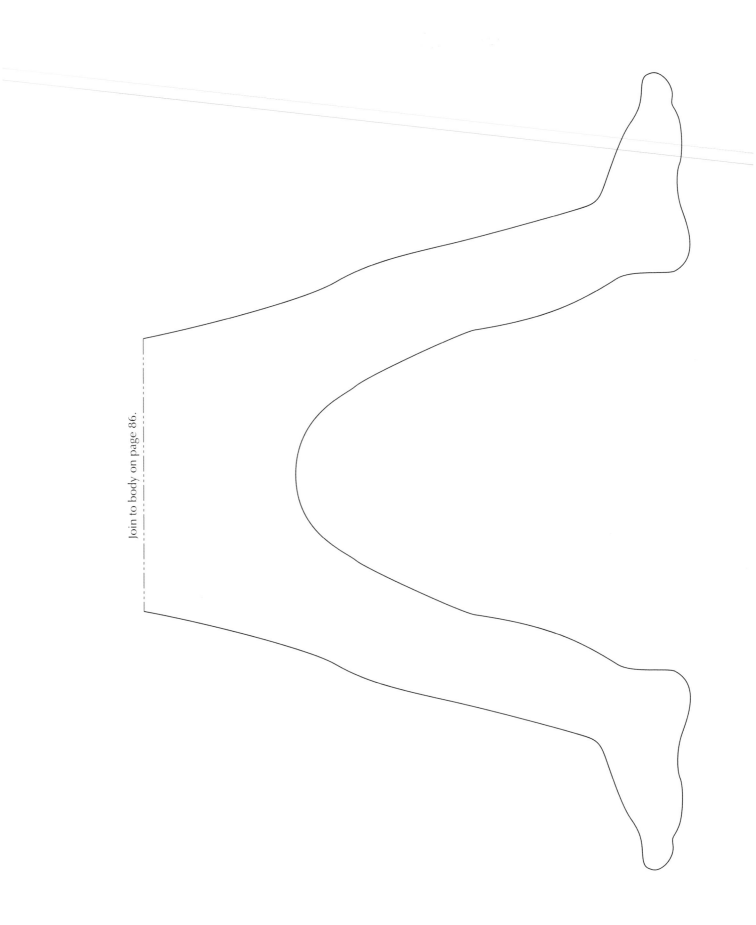

Join to body on page 86.

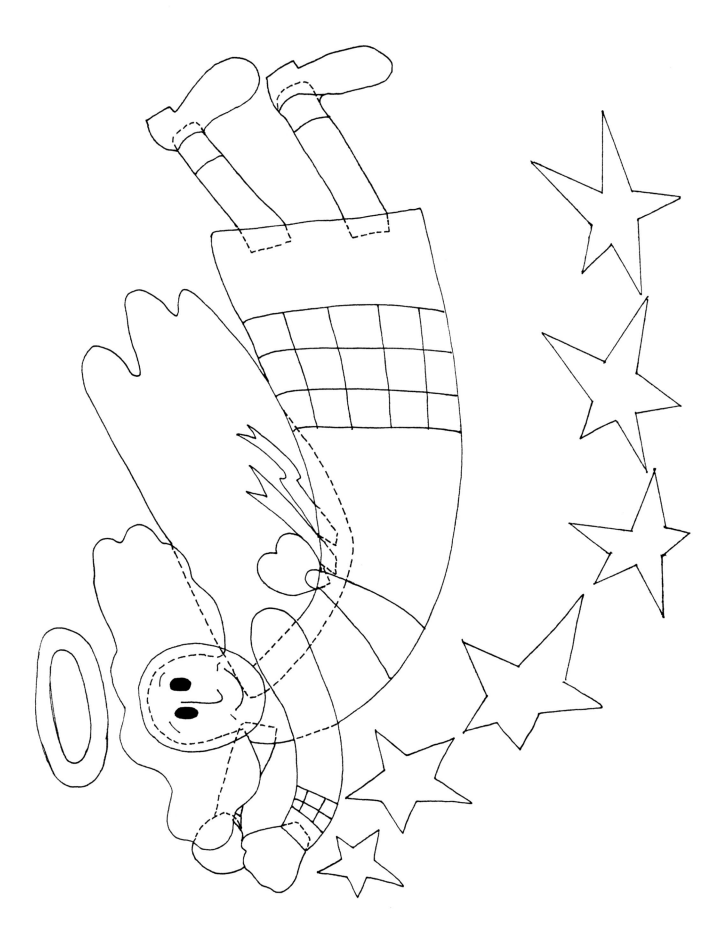

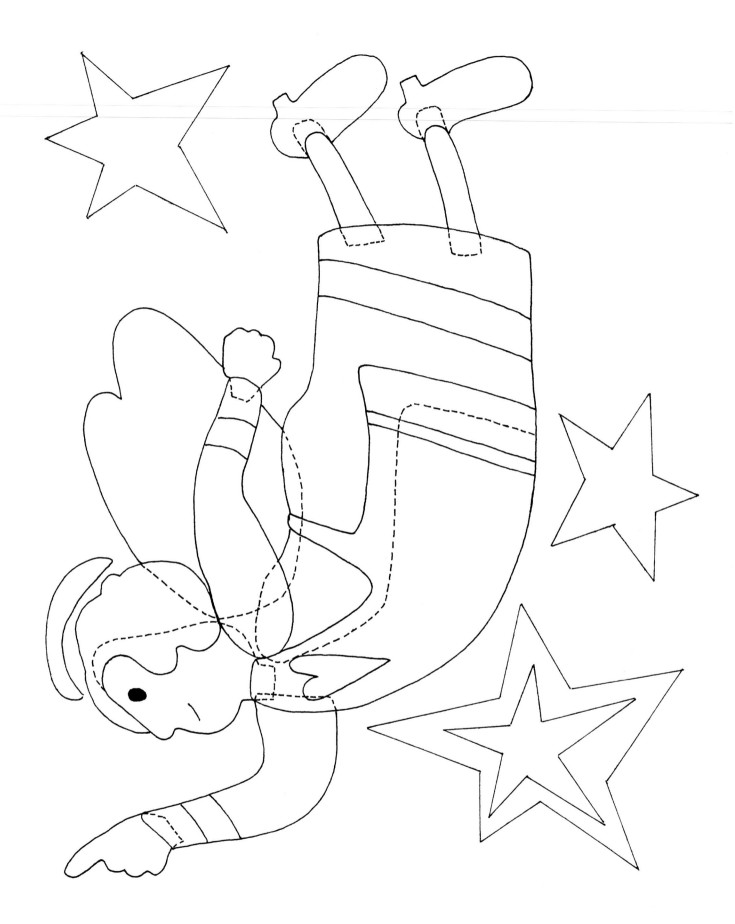

89

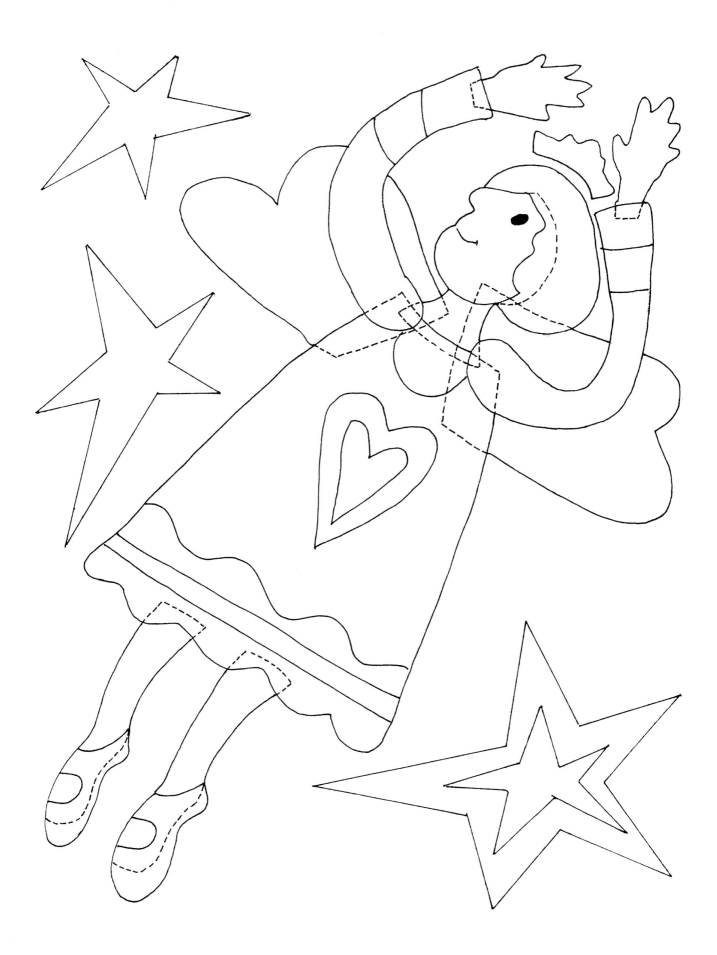

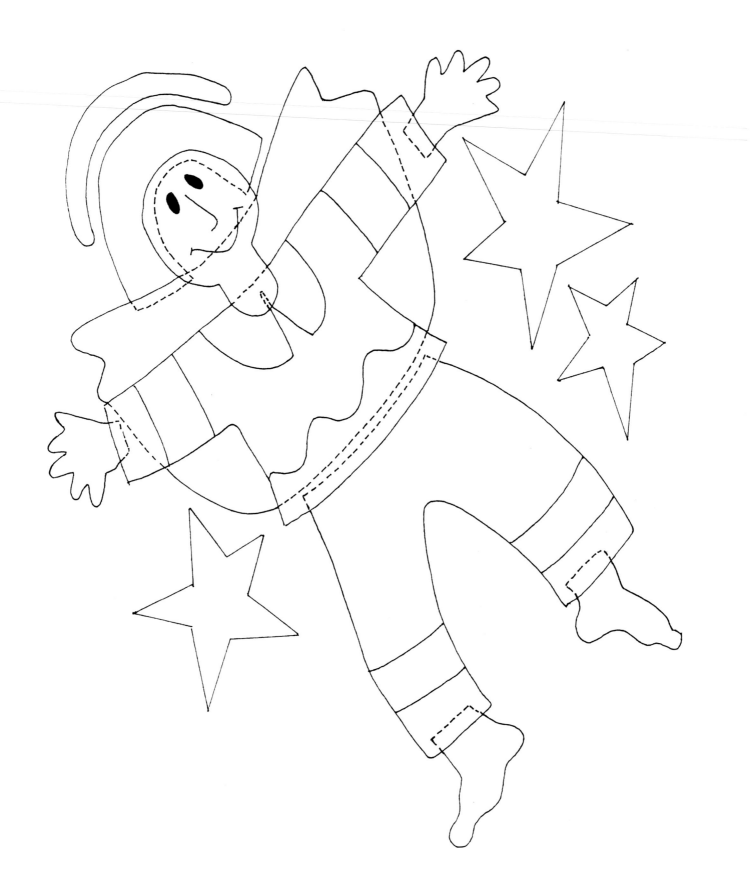

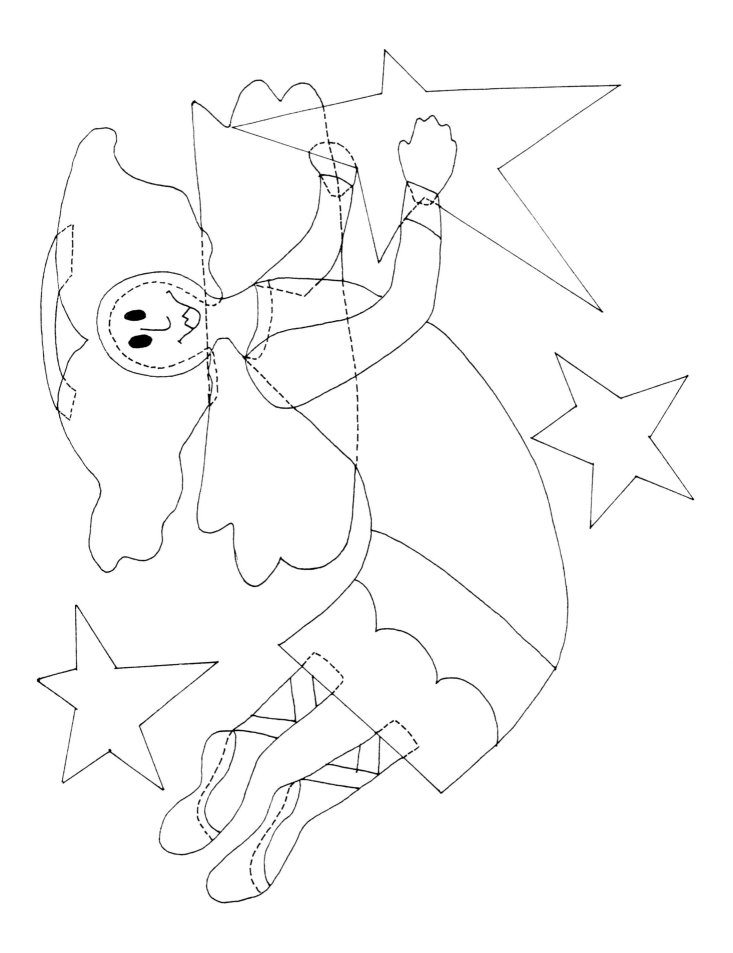

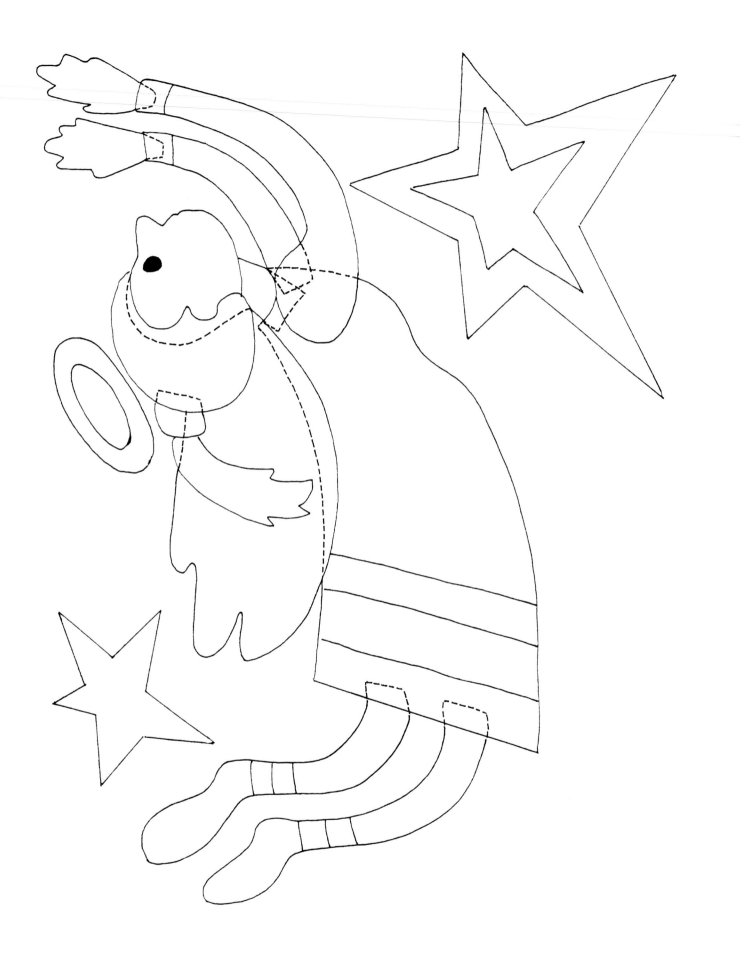

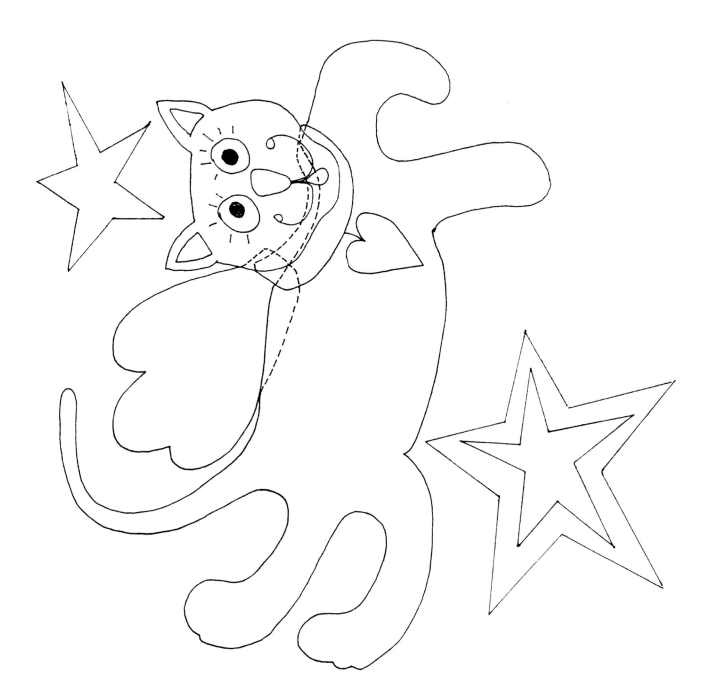

CREDITS

President . Nancy J. Martin
CEO/Publisher . Daniel J. Martin
Associate Publisher . Jane Hamada
Editorial Director .Mary V. Green
Technical Editor . Melissa A. Lowe
Design and Production Manager Cheryl Stevenson
Cover and Text Designer . Trina Stahl
Copy Editor . Liz McGehee
Technical Illustrations . Laurel Strand
Decorative Illustrations . Mary Lou Weidman
Photographer .Brent Kane

MISSION STATEMENT

We are dedicated to providing quality products and service by working together to inspire creativity and to enrich the lives we touch.

Everyday Angels in Extraordinary Quilts
© 1998 by Mary Lou Weidman
Martingale & Company, PO Box 118, Bothell, WA 98041-0118 USA

Printed in Hong Kong
03 02 01 00 99 98 6 5 4 3 2 1

Library of Congress Cataloging-in-Publication Data
Weidman, Mary Lou,
Everyday angels in extraordinary quilts / Mary Lou Weidman.
p. cm.
ISBN 1-56477-226-8
1. Patchwork. 2. Patchwork—Patterns. 3. Quilting.
4. Quilting—Patterns. 5. Angels in art. I. Title.
TT835.W443 1998
746.46'041—dc21 98-24782
 CIP

Everyday Angels in Extraordinary Quilts

MARY LOU WEIDMAN

& COMPANY

BOTHELL, WASHINGTON